365 DAYS
OF SMILES

WHITE STAR PUBLISHERS

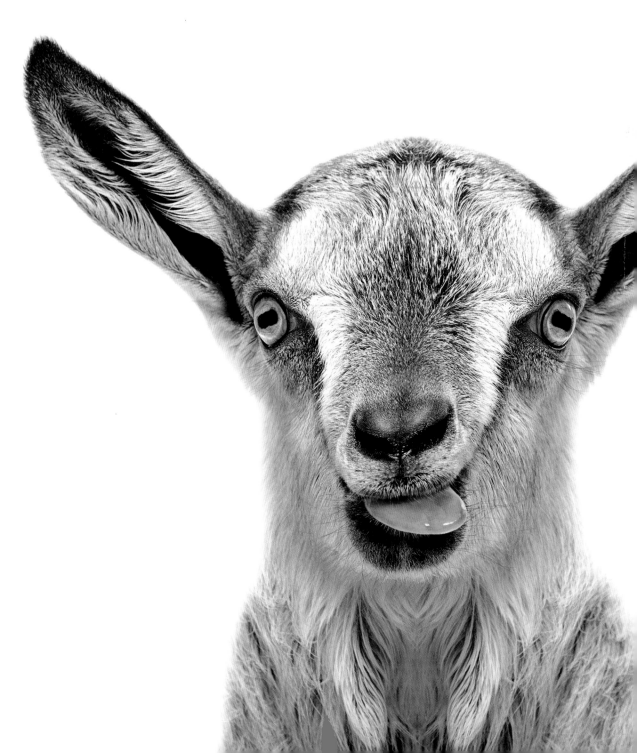

365 DAYS

OF SMILES

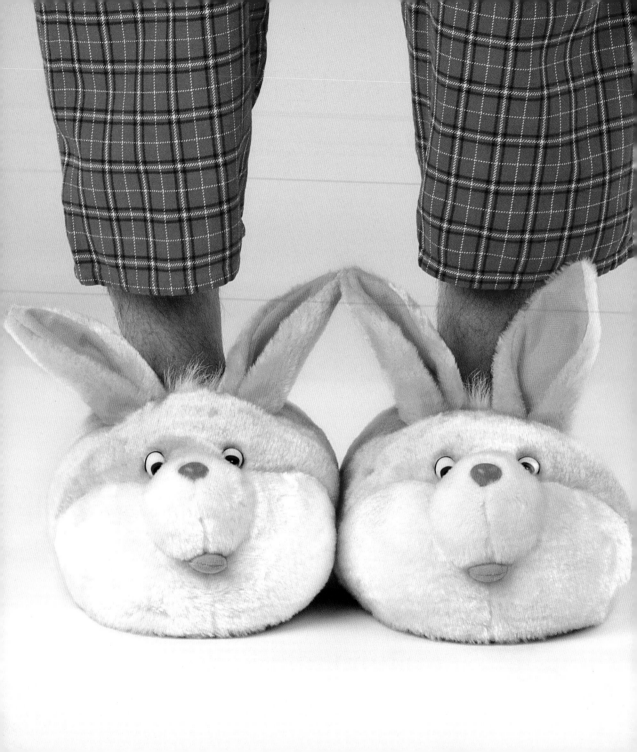

CONTENTS

THOSE WHO CAN LAUGH ARE MASTERS OF THE WORLD

SMILE, WE ARE

A tramp unexpectedly finds himself in a boxing ring and has to defend himself. He is used to having to find his way out of uncomfortable situations, so he hides behind the referee, shadowing him so that his opponent cannot reach him. Then he neutralizes his opponent in a pressing hug and holds on to him in a rhythmic dance that goes on for five minutes. The scene is from City Lights, *with Charlie Chaplin. Do you remember it? No dialogue, just images and a caricature figure stumbling around the ring. It was impossible to keep a straight face. It was everyday life made absurd, where Chaplin was incapable of dealing with commonplace situations, so he improvised, navigating the maze of reality while making fun of it. This is the great gift of irony. No anxiety, no panic: we are human and we do things our own way.*

Mutatis mutandis, if we gave equal weight to every situation, the world would seem simpler. Let it be clear that it is not a question of trivializing life, but simply of wearing the invincible cloak of irony in our approach to it.

Think about it: how often do we laugh, despite our daily concerns and duties, despite our problems and troubles? We laugh instinctively as a positive reaction, but do we do it enough? Apparently not. Our ability to laugh begins in the womb. But as we grow, we tend to lose our spontaneity along with our lightheartedness. Children smile as often as four hundred times a day, adults only about twenty. There is no doubt that the little ones are better at it: they laugh when a clown gets a cream pie in the face, when Disney's Pluto slips on a banana peel, or when the Road Runner outsmarts Wile E. Coyote. It is simple enough to understand:

HUMAN

children learn to laugh before they learn to speak, and they do it instinctively. A smile may only last a moment, but its effect is persistent and is slow to fade. A smile is not just a result but also a cause: it makes us feel good. It eases our stress and anxiety, our rage and our fear, helping us to live and to overcome moments of difficulty. It triggers positive emotions, such as optimism and joy. It strengthens our immune system and helps us to heal; it extends our life. Laughter is truly the best medicine.

In fact, smiling affects the chemistry of the brain, causing it to release endorphins, the feel-good hormones: the same ones that are "unleashed" when we do something we like, such as listening to a favorite song or eating good food, hugging someone we love or stroking the fur of a purring cat. If a smile is sufficient for our bodies to produce endorphins, just think what gales of laughter can do! Much better than a thousand bars of chocolate with absolutely no calories!

Laughing is the best way to take care of ourselves. Happiness is not limited to the expression on our mouths; it reaches our eyes, our faces, and our entire bodies. "She has laughing eyes," we say. Why resort to creams, massages, and treatments when an upturned curve under your nose is enough to make you more attractive, younger, and brighter?

"A smile is the shortest distance between two people," said Victor Borge. It is a bridge, a message of sociality and closeness, a message that needs no words and that everyone can perceive, even someone who does not speak your language.

It is much easier to get close to others with a pleasant smile than with a sad face or a trembling voice. A smile makes us more likable and gives us confidence. It communicates closeness and intimacy. At times, it replaces a greeting; it is the primordial form of recognition. "Is that really you?" (Smile). "Yes, I recognized you, too!" (Another smile). As we all know, it is an extremely contagious gesture. Love is repaid with love: it is difficult not to reciprocate. Have you ever tried to remain serious when someone in front of you is laughing? This joy is triggered by empathy, our wonderful and innate capacity to relate to others. We may not even know the person we are observing, but we are still able to recognize their emotions, to internalize them and imitate them because the same cerebral cells are activated in us: the mirror neurons. Our feelings are reflected by our surroundings, by the people in our lives, by our vision of the world. So, the secret of success is quite simple—smile. Every day of the year, to start out on the right foot, or to ease a difficult day. All it takes is to appreciate the small things, the details that brighten up our world, the amusing circumstances that deviate from normality and give us a break from the monotony of daily life. Let's wear a pair of colorful socks, carve a smile into the sandwich we make for lunch. Let's be touched by a child making faces or a puppy that gives us its paw.

Most importantly, let's laugh at ourselves, the highest form of awareness. With kindness, never with malice, let's laugh with others at themselves. Let's laugh until we cry about a well-played joke or a surprise ending or funny story—even if we are the last one to catch on. Let's make light of difficult or

embarrassing situations and laugh at our misadventures: after all, to err is human. Let's recognize ourselves in those absurd but amusing situations we all end up in from time to time—how lazy we are or how greedy we are or how strange we are. "Wrinkles are hereditary. Parents get them from their children," said Doris Day. In the end, habits are universal; the same vices and the same virtues.

This book is a starting point, an incentive to take the first step: a collection of clever lines and funny images to make you laugh, or simply smile, from January to December, whenever you need it most.

Some of the quotations are from people who made humor their profession, from Groucho Marx to Steven Wright, and some belong to people from other walks of life—singers, athletes, politicians, and entrepreneurs. Ironizing about daily life, about situations we all endure—, Jackie Gleason said, "The second day of a diet is always easier than the first. By the second day you're off it." From classic authors and contemporary writers come these pearls of wisdom and proverbs with their picturesque truths, proof of the fact that laughter is everywhere and is timeless.

If you want to live longer, feel happier, and be more attractive, and if you want to be a boon to those around you, start turning the pages of this book, and above all—remember to smile.

Giulia Gatti and Chiara Schiavano

1

January

There's one good
thing about snow,
it makes your lawn look
as nice as your neighbor's.

– Clyde Moore

JANUARY

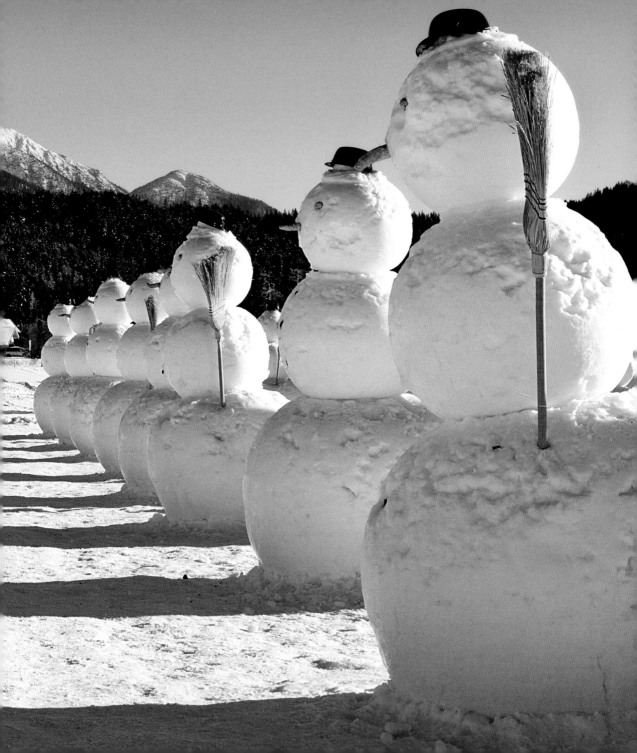

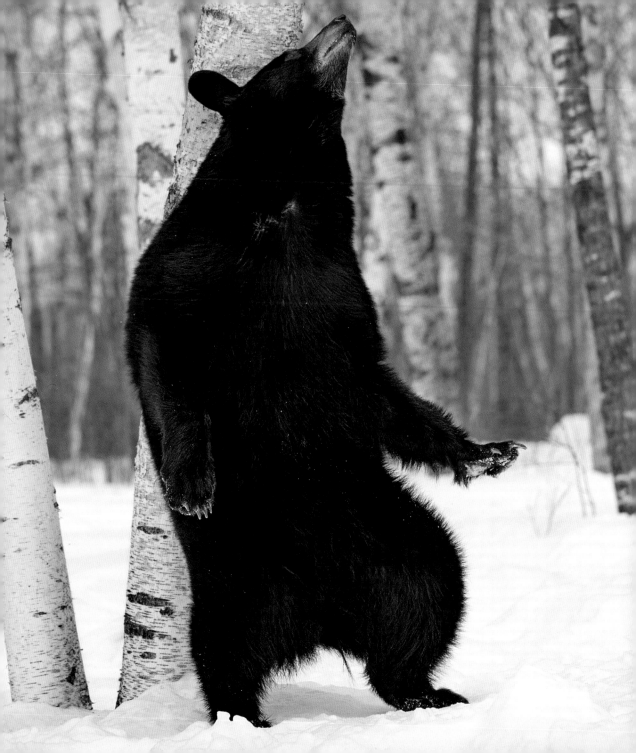

2

January

I base most
of my fashion taste
on what doesn't itch.

– Gilda Radner

3

January

Happiness is having
a scratch for every itch.

– Ogden Nash

4

January

Always wear cute pajamas to bed,
you'll never know who
you will meet in your dreams.

– Joel Madden

5

January

A balanced diet
is a cookie in each hand.

– Barbara Johnson

6

January

You have a more interesting life
if you wear impressive clothes.

– *Vivienne Westwood*

7

January

A line is a dot that
went for a walk.

– *Paul Klee*

8

January

All parts of the human body get tired
eventually—except the tongue.

– Konrad Adenauer

9

January

Primates feel pure, flat immobility
as boredom. But dogs feel it as peace.

– Elizabeth Marshall Thomas

10

January

Sunset is still my favorite color,
and rainbow is second.

– *Mattie Stepanek*

11

January

I can't be funny
if my feet don't feel right.

– *Billy Crystal*

12

January

When you stretch the truth,
watch out for the snap back.

– Bill Copeland

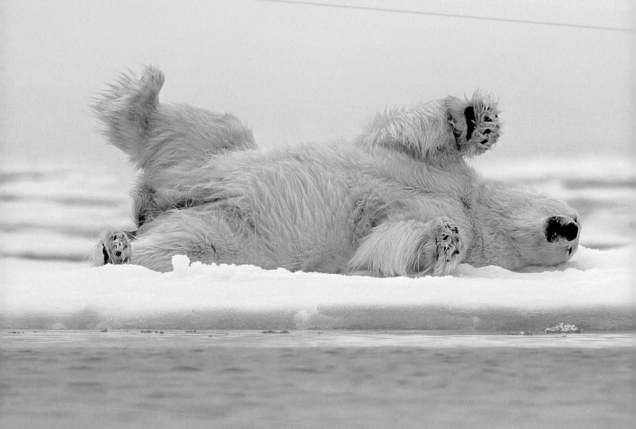

13

January

Lazy people are always anxious
to be doing something.

– Luc de Clapiers de Vauvenargues

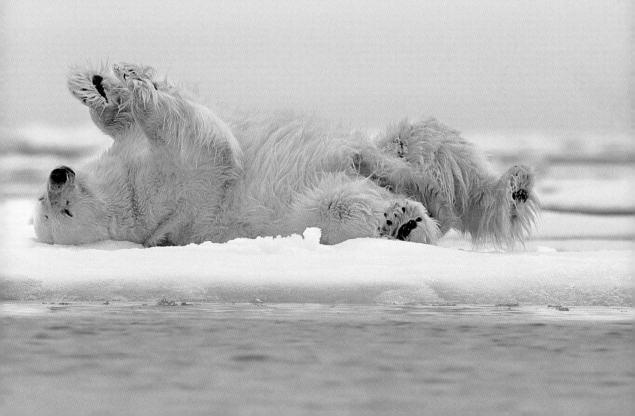

14

January

Good company in a journey
makes the way seem shorter.

– Izaak Walton

15

January

The most valuable antiques
are dear old friends.

– H. Jackson Brown Jr.

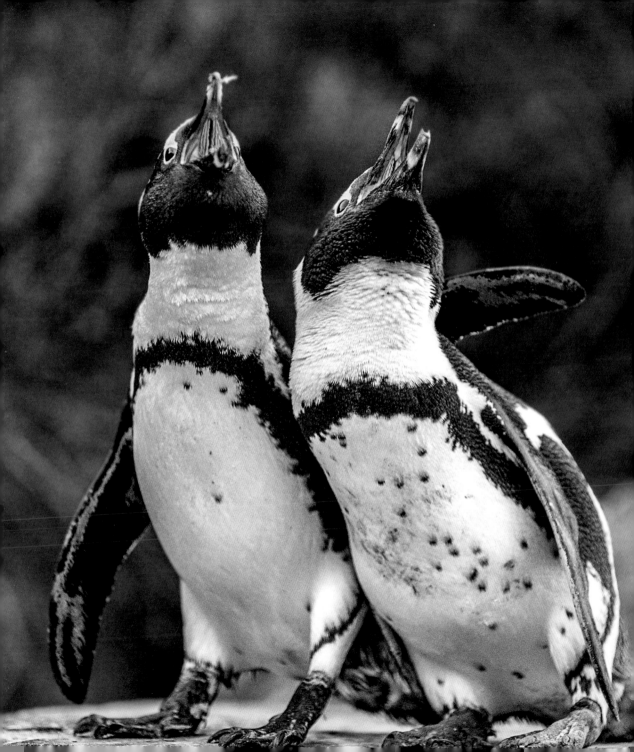

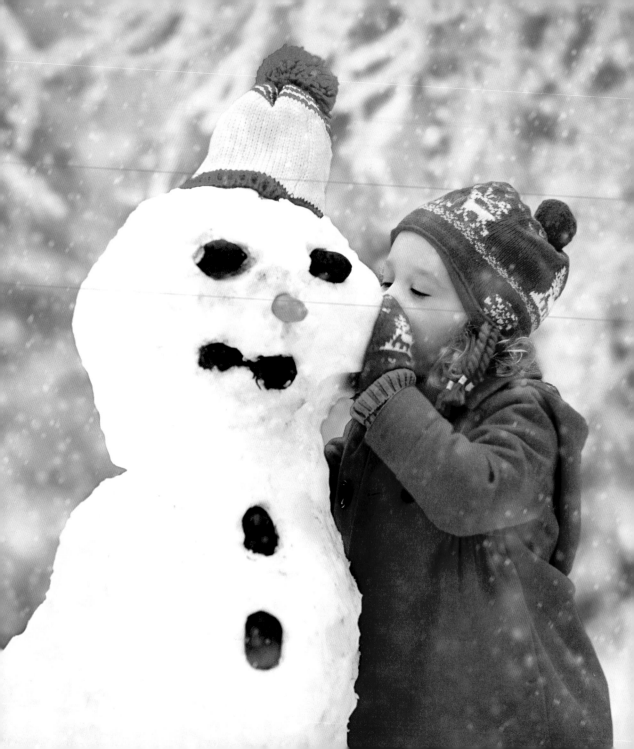

16

January

One advantage of talking to yourself
is that you know at least
somebody's listening.

– Franklin P. Jones

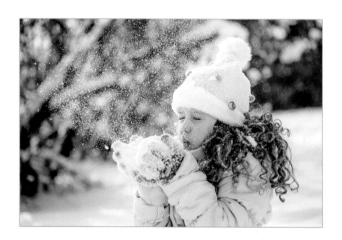

17

January

A snowball in the face is surely the
perfect beginning to a lasting friendship.

– Markus Zusak

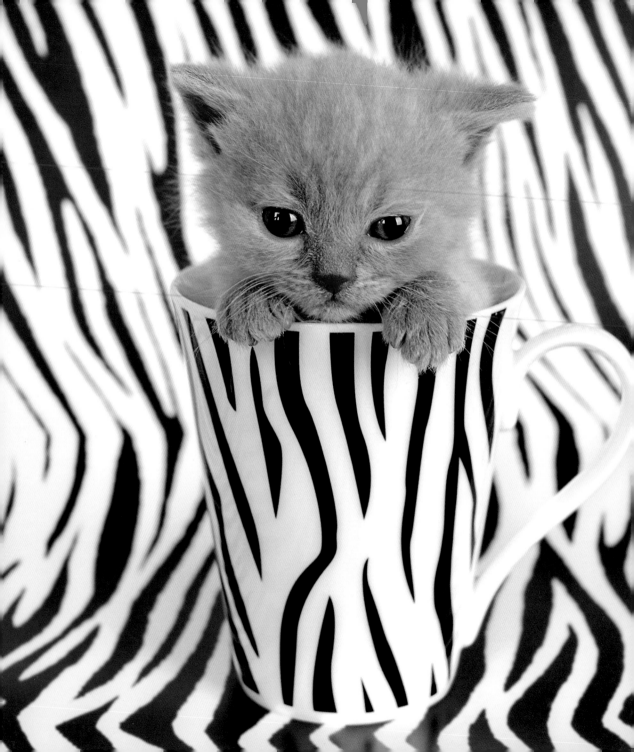

18

January

Even a bad cup of coffee
is better than no coffee at all.

– David Lynch

19

January

Zebras are just horses
that escaped from prison.

– Bill Murray

20

January

I don't have a fear of flying;
I have a fear of crashing.

– Billy Bob Thornton

21

January

I've always wanted to smash a guitar over
someone's head. You just can't do that with a piano.

– Elton John

22

January

When a man's best friend is his dog,
that dog has a problem.

– Edward Abbey

23

January

My mother had a great deal of trouble
with me, but I think she enjoyed it.

– Mark Twain

24

January

I lie without a mask,
thus I am an honest man.

– *Lionel Suggs*

25

January

The portrait of my parents is a
complicated one, but lovingly drawn.

– *Joyce Maynard*

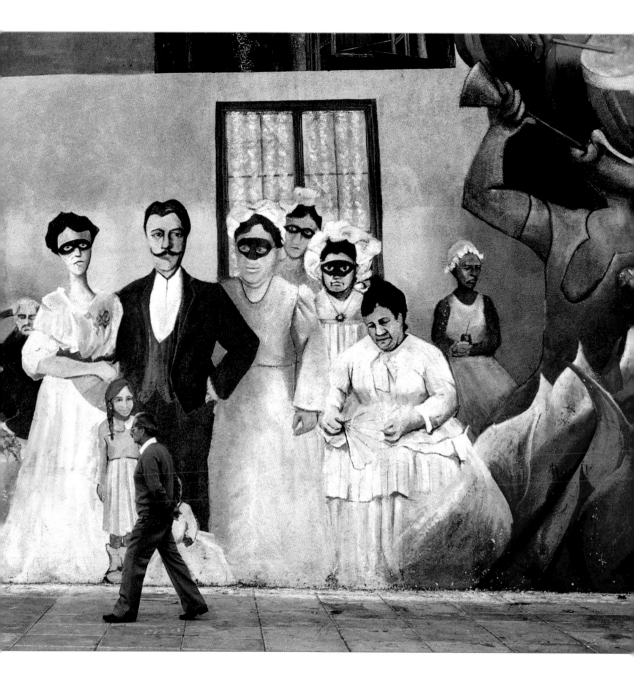

26

January

Many a man who thinks to found a home
discovers that he has merely opened
a tavern for his friends.

– Norman Douglas

27

January

Home is wherever I hang my hat.

– Miriam Margolyes

28

January

If you see all gray,
move the elephant!

– Indian proverb

29

January

I have a memory like an elephant.
In fact, elephants often consult me.

– Noël Coward

30

January

When I no longer thrill to the first snow
of the season, I'll know I'm growing old.

– Lady Bird Johnson

31

January

When it snows you have two choices:
shovel or make snow angels.

– Anonymous

1

February

I can't understand why
people are frightened of new ideas.
I'm frightened of the old ones.

– John Cage

FEBRUARY

2

February

As men get older,
the toys get
more expensive.

– *Marvin Davis*

3

February

I'm leaving because
the weather is too good.
I hate London when it's not raining.

– *Groucho Marx*

4
February

Some people are worth
melting for.

– Olaf, from the animated movie "Frozen"

5
February

If a player's not doing the things he should,
put him on the bench. He'll come around.

– John Wooden

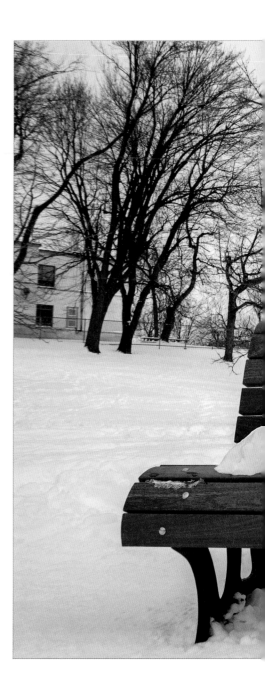

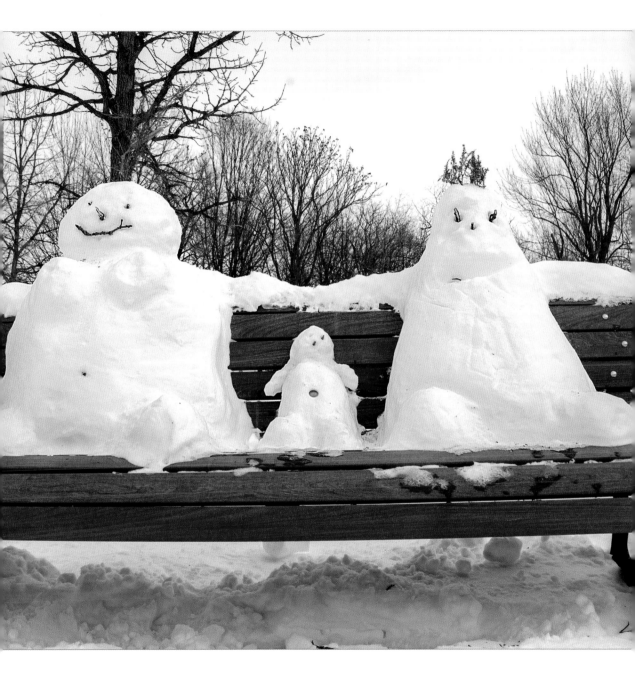

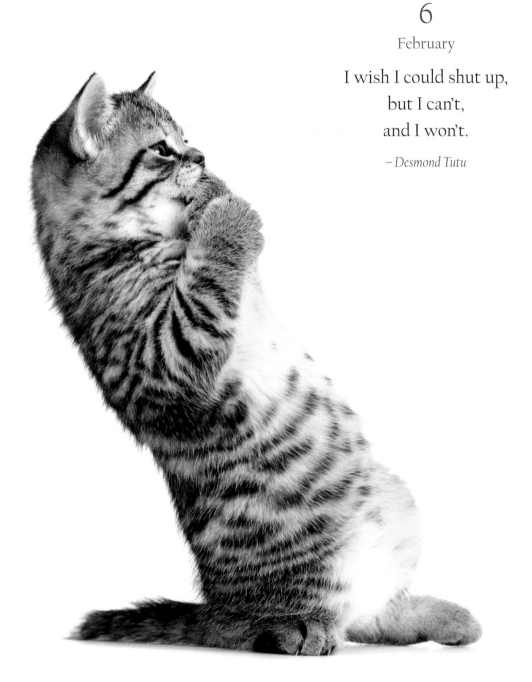

6

February

I wish I could shut up,
but I can't,
and I won't.

– Desmond Tutu

7

February

Wrinkles are hereditary.
Parents get them from their children.

– *Doris Day*

8

February

A squirrel is just a rat
with a cuter outfit.

– Sarah Jessica Parker

9

February

You can't climb the ladder of success
with your hand in your pockets.

– Arnold Schwarzenegger

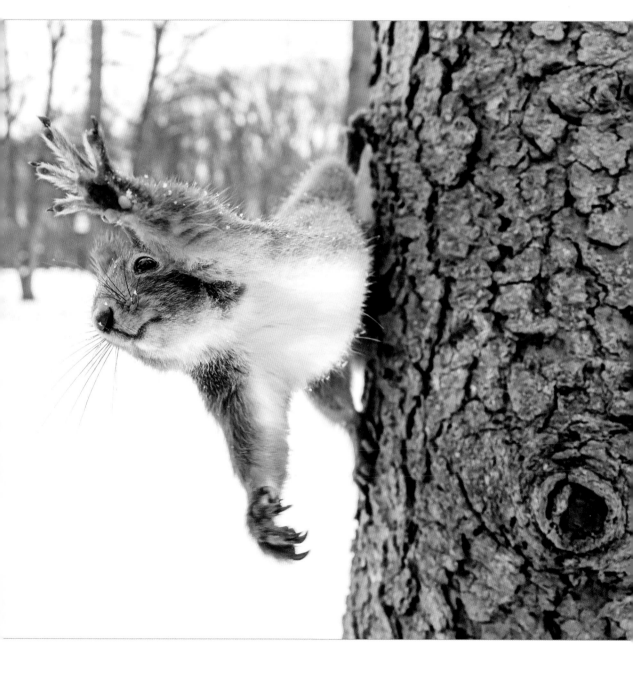

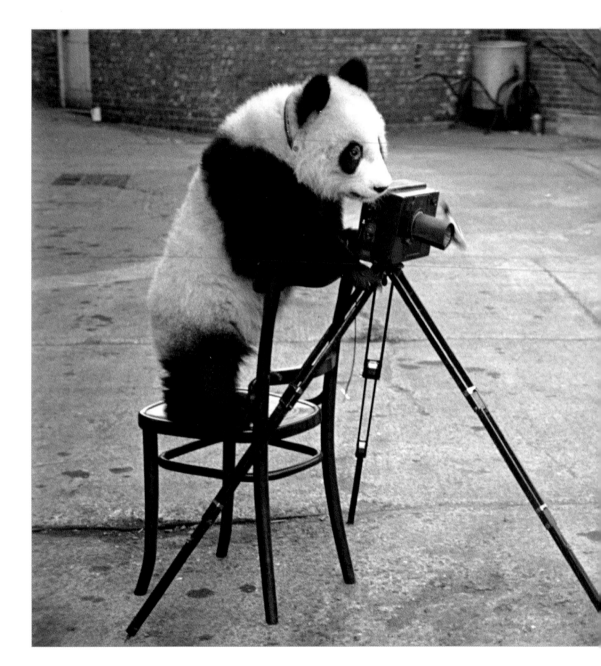

10
February

Who sees the
human face correctly:
the photographer,
the mirror,
or the painter?

– Pablo Picasso

11
February

Pandas:
proof that you can eat
just bamboo
and still be fat.

– Anonymous

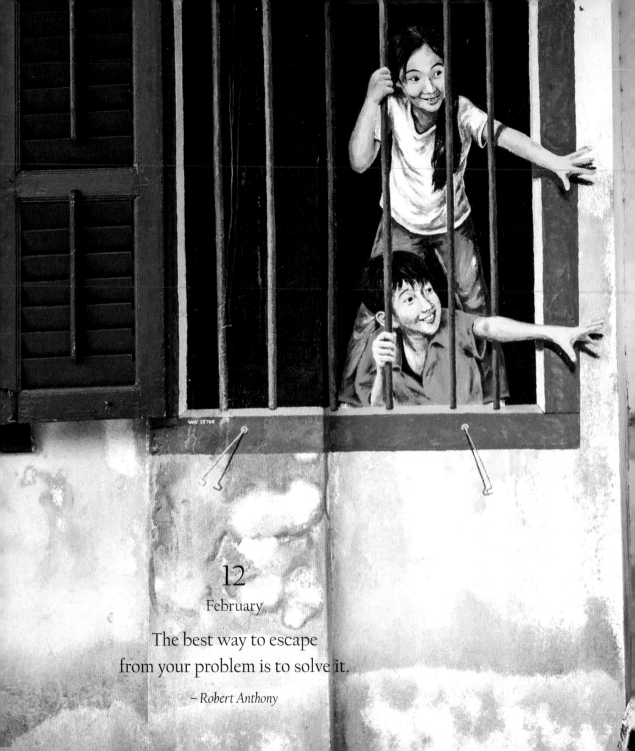

12

February

The best way to escape
from your problem is to solve it.

– *Robert Anthony*

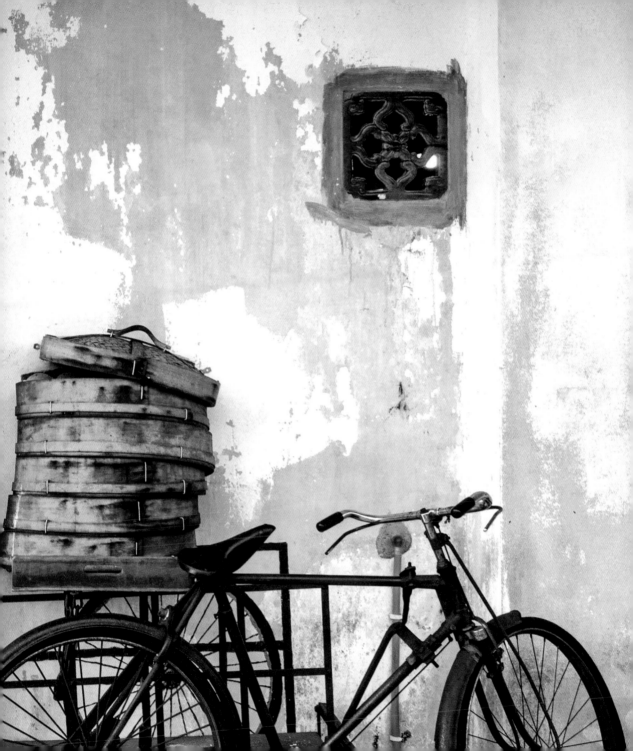

13

February

He is so shy that when he rings
someone's doorbell, he hopes they
won't answer the door . . .

– Roberto Gervaso

14

February

If love is the answer,
could you please
rephrase the question?

– Lily Tomlin

15
February

When opportunity knocks,
open the door—even if
you're in your bathrobe.

– Heather Zschock

16
February

You really don't need to study how
to change a diaper. As a new mom,
you learn pretty darn quickly!

– Ivanka Trump

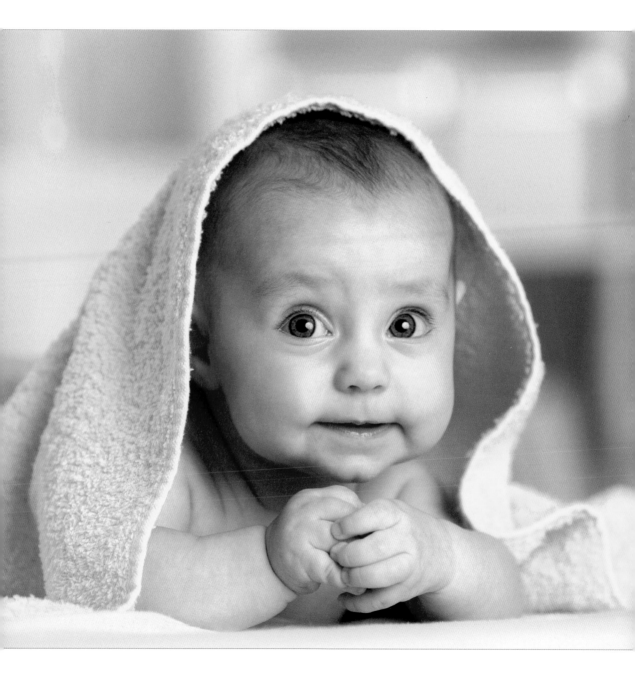

17
February

Compared to other animals,
the bear is at an advantage. He doesn't
have to dress up for Carnival.

– Gene Gnocchi

18
February

The best way
of being kind to bears
is not to be very close to them.

– Margaret Atwood

19

February

My son complains about headaches. I tell him
all the time, when you get out of bed, it's feet first!

– Henny Youngman

20

February

They laugh at me because I'm different;
I laugh at them because they're all the same.

– Kurt Cobain

21

February

Thankfully, persistence
is a great substitute for talent.

– Steve Martin

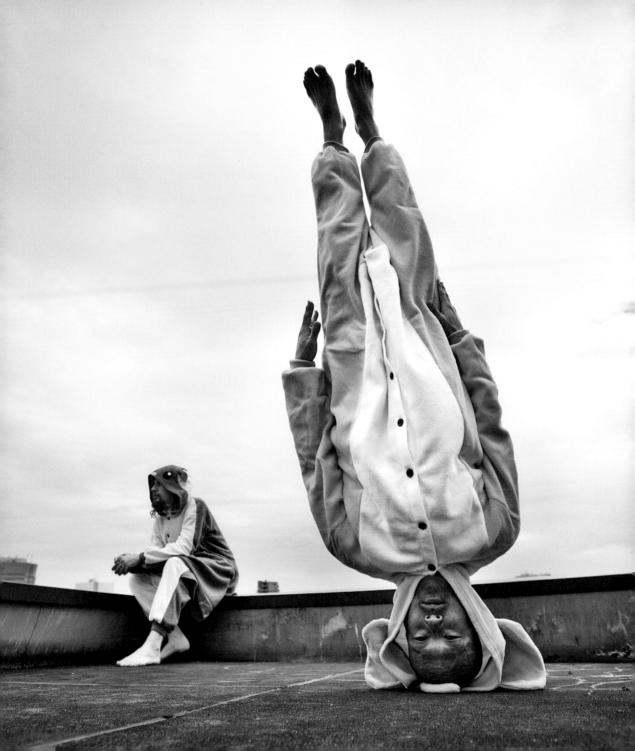

22

February

The key to everything is patience. You get the chicken
by hatching the egg, not by smashing it.

– Arnold H. Glasow

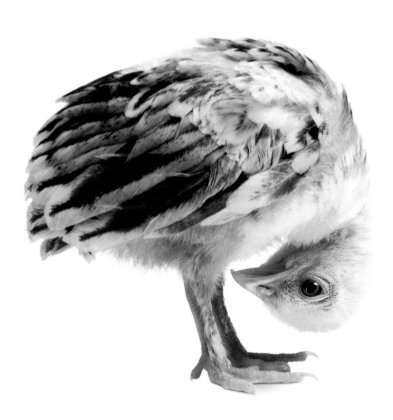

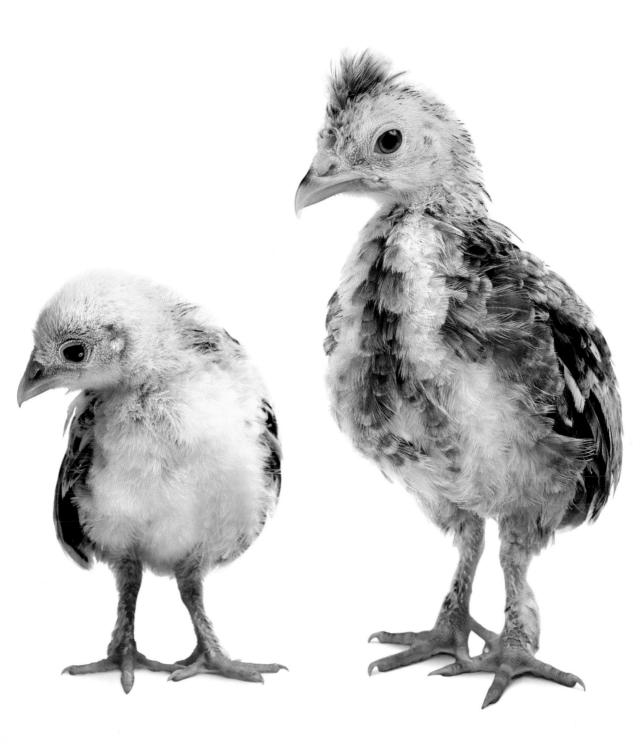

23

February

I decided that if I could paint
that flower in a huge scale,
you could not ignore its beauty.

– Georgia O'Keeffe

24

February

I paint flowers
so they will not die.

– Frida Kahlo

25

February

When Solomon said there was a time and a place for everything he had not encountered the problem of parking his automobile.

– Bob Edwards

26

February

I've just solved
the parking problem.
I bought a parked car.

– Henny Youngman

27

February

A true freak cannot be made.
A true freak must be born.

– Katherine Dunn

28/29

February

I find only freedom
in the realms of eccentricity.

– David Bowie

1

March

Every problem
has three solutions:
yours, mine,
and the right one.

– Plato

MARCH

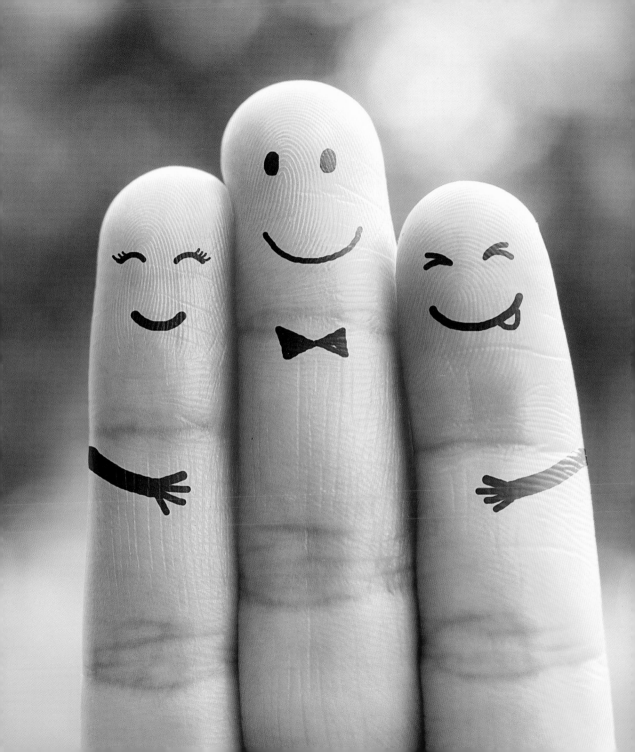

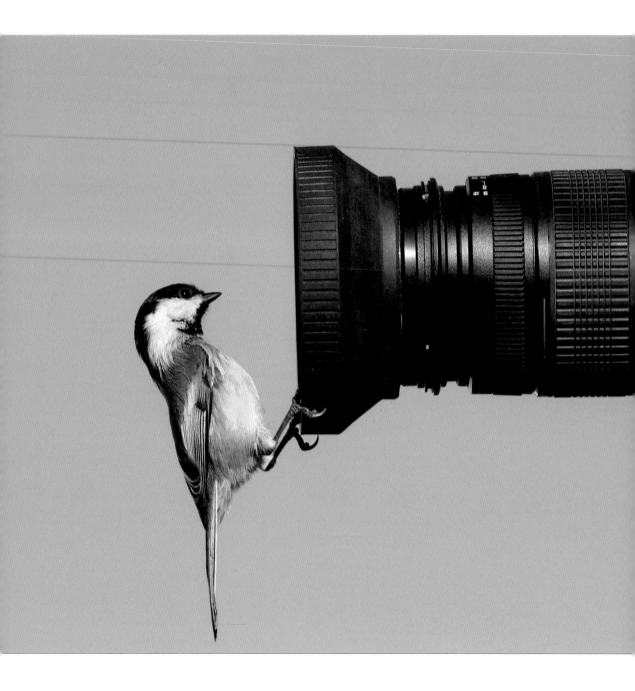

2

March

There are always two people in every picture: the photographer and the viewer.

– Ansel Adams

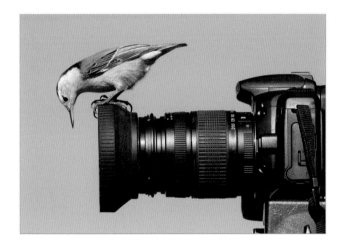

3

March

One time, a guy handed me a picture and said, "Here's a picture of me when I was younger." Every picture of you is when you were younger.

– Mitch Hedberg

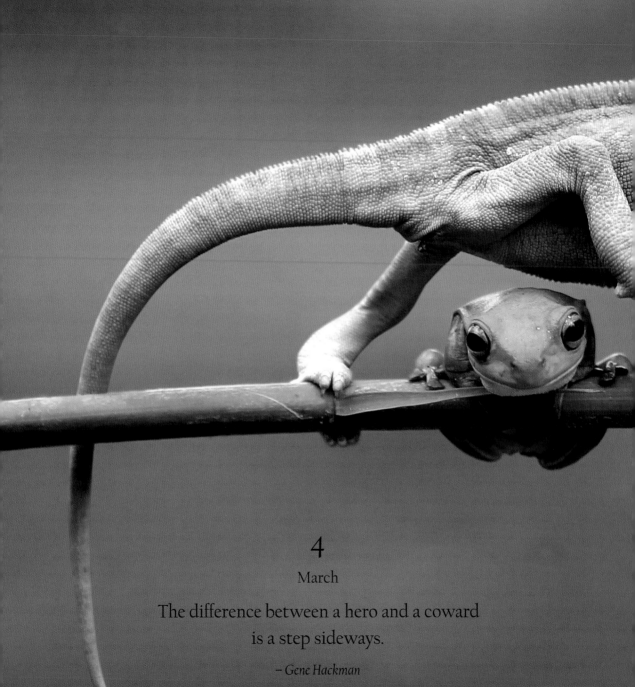

4

March

The difference between a hero and a coward
is a step sideways.

– *Gene Hackman*

5

March

The only use of an obstacle
is to be overcome.

– *Thomas Woodrow Wilson*

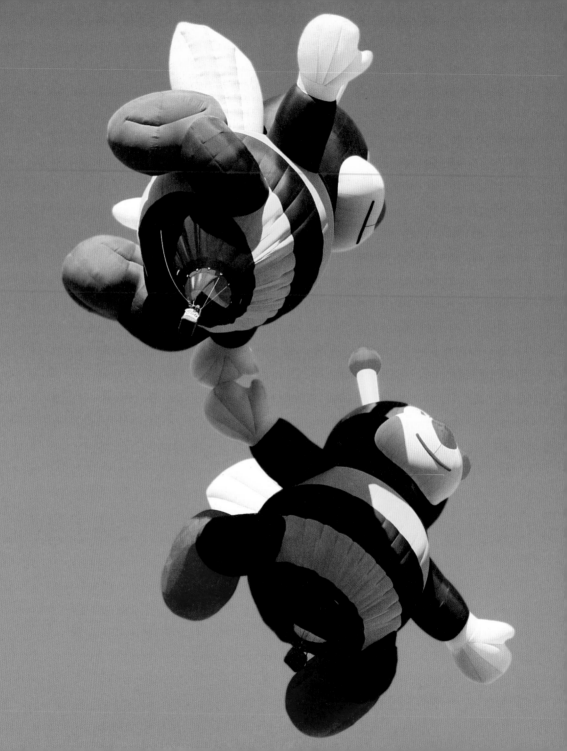

6
March

A bee is never as busy as it seems;
it's just that it can't buzz any slower.

– *Kin Hubbard*

7
March

The sky is the daily bread
of the eyes.

– *Ralph Waldo Emerson*

8

March

It's time to renew that gym membership
we're never going to use again.

– Anonymous

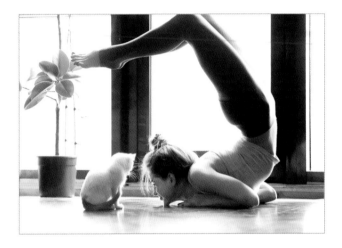

9

March

In theory, there is no difference between
theory and practice. But in practice, there is.

– Yogi Berra

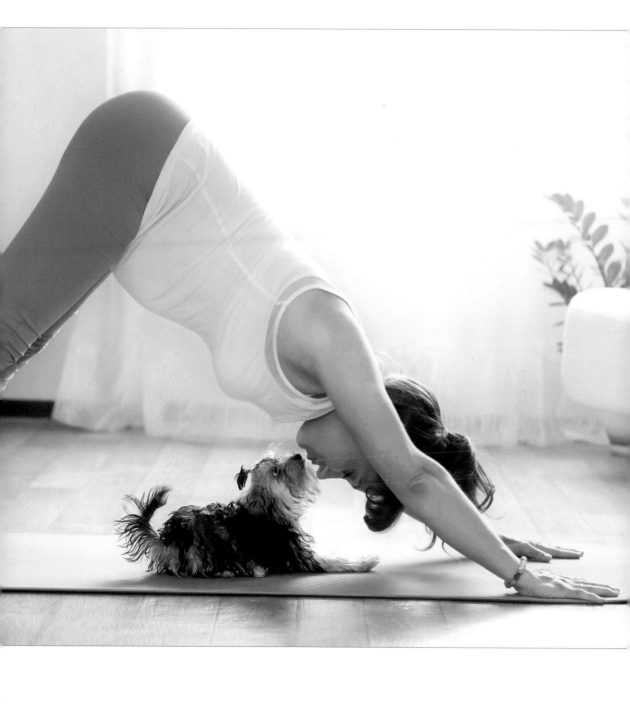

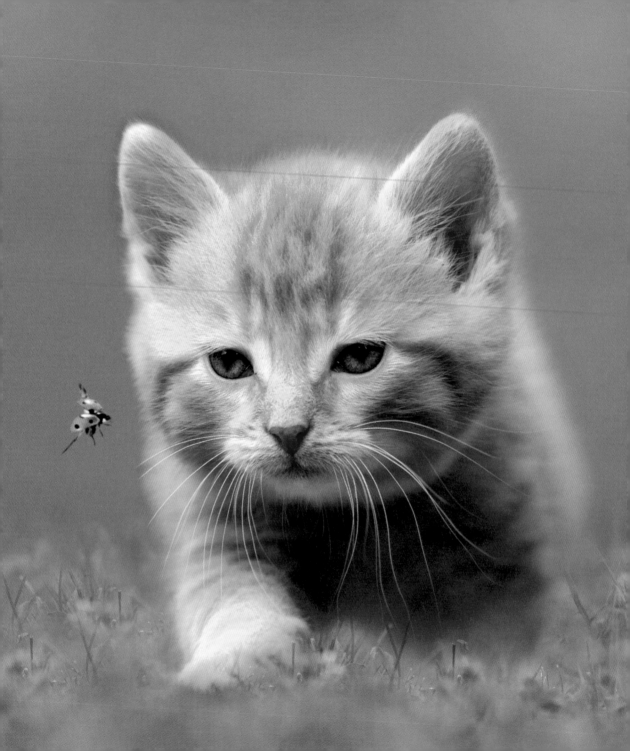

10

March

Cats are
smarter than dogs.
You can't get
eight cats to pull
a sled through snow.

– Jeff Valdez

11

March

I have no special talent.
I am only passionately curious.

– Albert Einstein

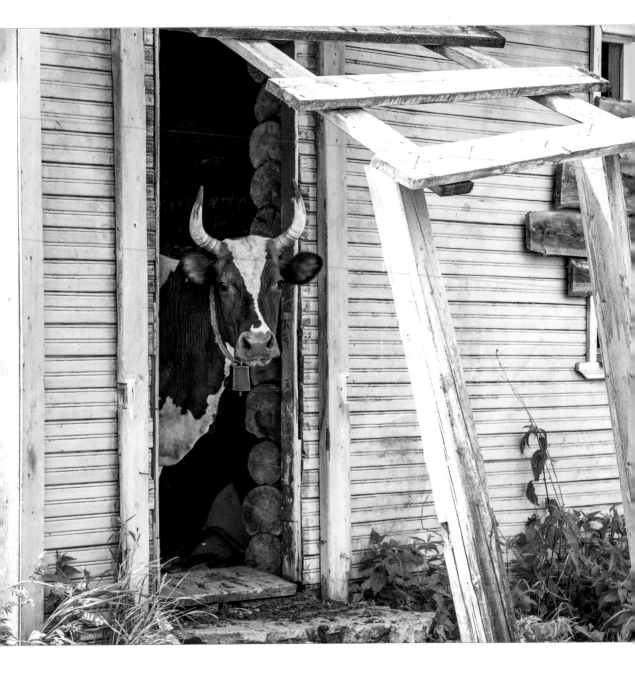

12
March

Love your neighbor
as yourself; but don't
take down the fence.

– Carl Sandburg

13
March

I chose my house because I loved
the fact that there was a really busy road
with lots of thing to stare at.

– Kate Williams

14

March

Most cats
when they are out
want to be in, and vice versa,
and often simultaneously.

– *Louis J. Camuti*

15

March

Feet, what do I need you for
when I have wings to fly?

– *Frida Kahlo*

16

March

It was soon noticed that
when there was work to be done
the cat could never be found.

– *George Orwell*

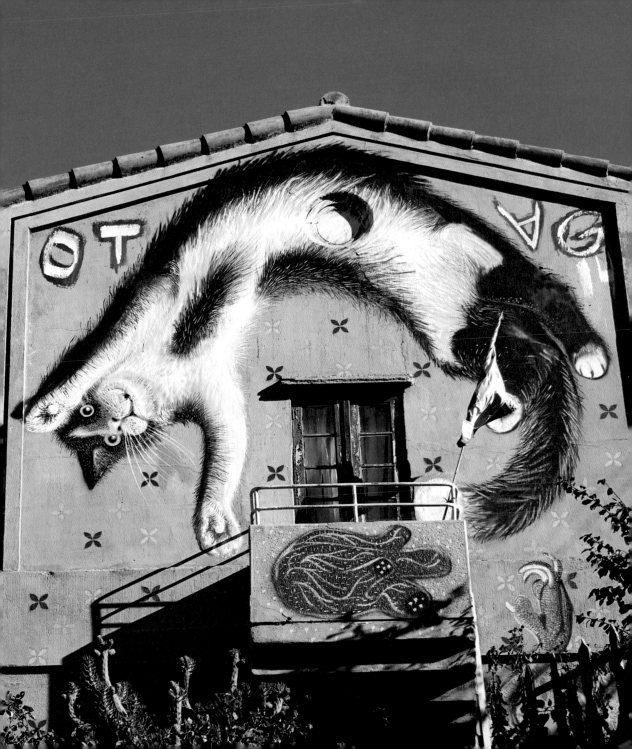

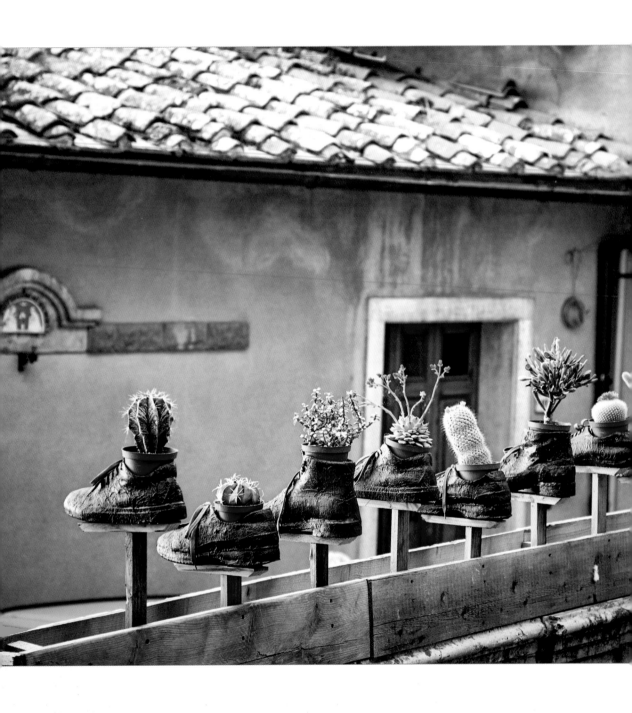

17
March

I still have my feet on the ground,
I just wear better shoes.

– *Oprah Winfrey*

18
March

What should you do when you see
an endangered animal eating
an endangered plant?

– *George Carlin*

19

March

I never wear mascara;
I laugh until I cry too often.

– Jeanne Calment

20

March

If you obey all the rules,
you miss all the fun.

– Katharine Hepburn

21

March

Art, freedom, and creativity
will change society faster than politics.

– Victor Pinchuk

22

March

Sixty-five million years ago
the dinosaurs had a bad day.

– Phil Plait

23

March

Remember my mantra:
distinct . . . or extinct.

– Tom Peters

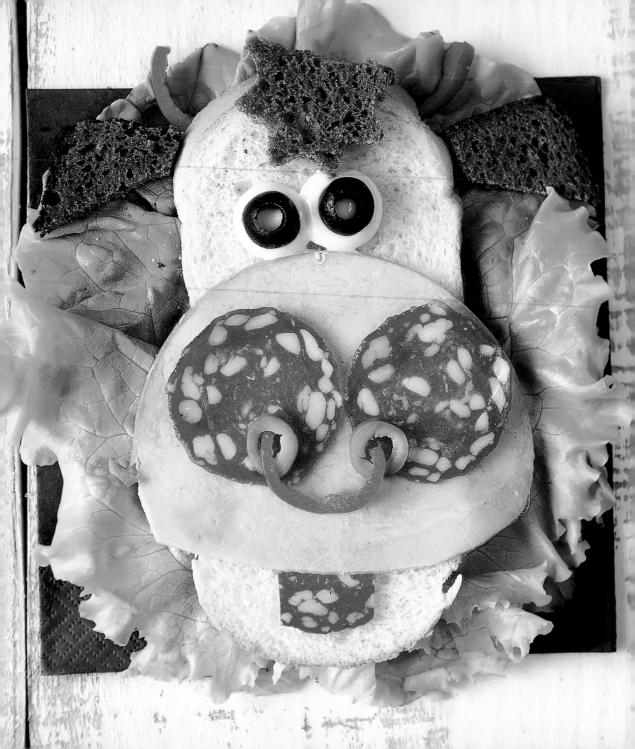

24

March

I never forget a face, but in your case
I'll be glad to make an exception.

– Groucho Marx

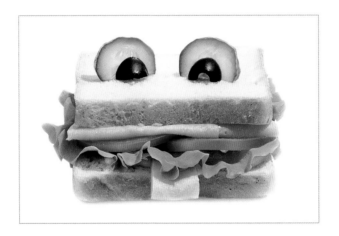

25

March

The second day of a diet
is always easier than the first.
By the second day, you're off it.

– Jackie Gleason

26
March

My friends call me an owl. Apparently, it's a combination of being wise and having big eyes.

– Romy Madley Croft

27

March

My first job is big sister
and I take that very seriously.

– *Venus Williams*

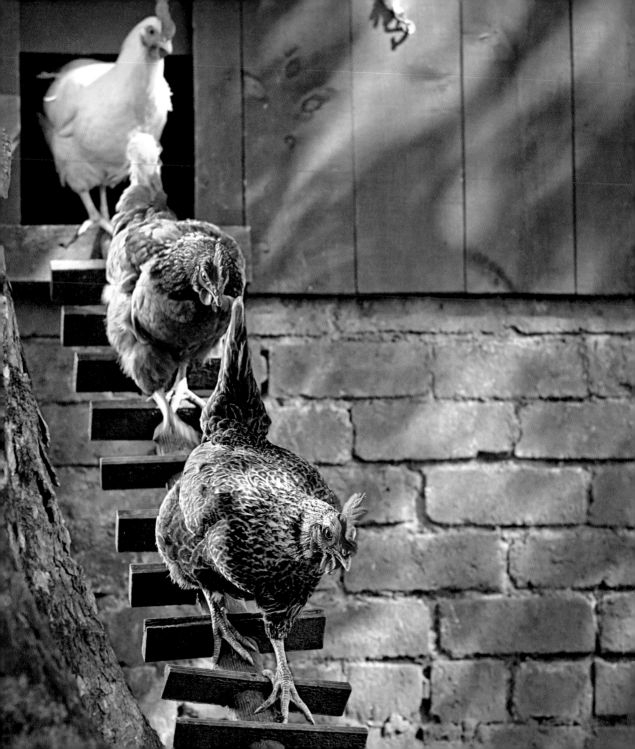

28

March

I go on working for the same reason
that a hen goes on laying eggs.

– Henry L. Mencken

29

March

You cannot push any one
up a ladder unless he be willing
to climb a little himself.

– Andrew Carnegie

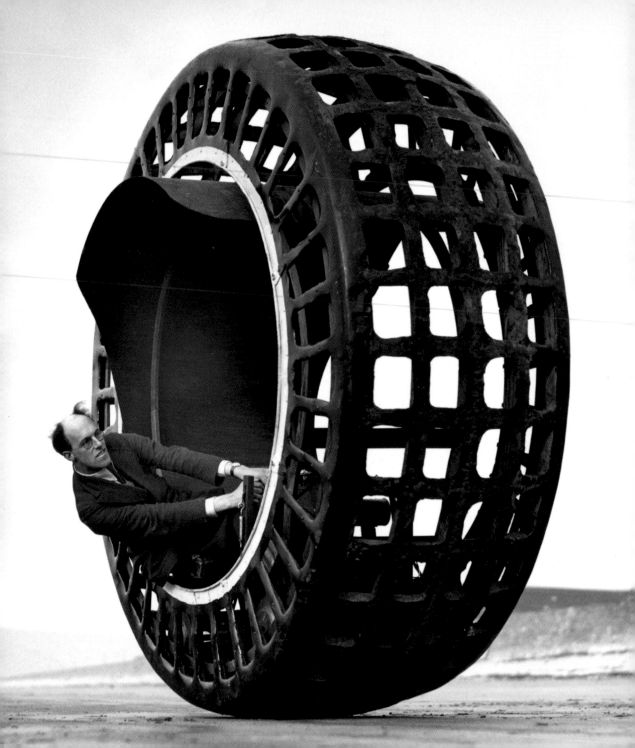

30

March

Life is like riding a bicycle.
To keep your balance,
you must keep moving.

– Albert Einstein

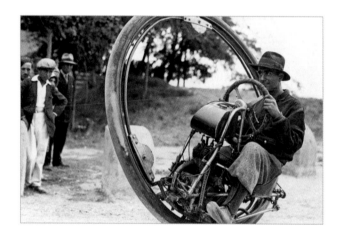

31

March

A goal without a plan
is just a wish.

– Antoine de Saint-Exupéry

1

April

Dance for yourself.
If someone else understands, good.
If not, no matter. Go right on doing
what interests you, and do it until
it stops interesting you.

– Louis Horst

APRIL

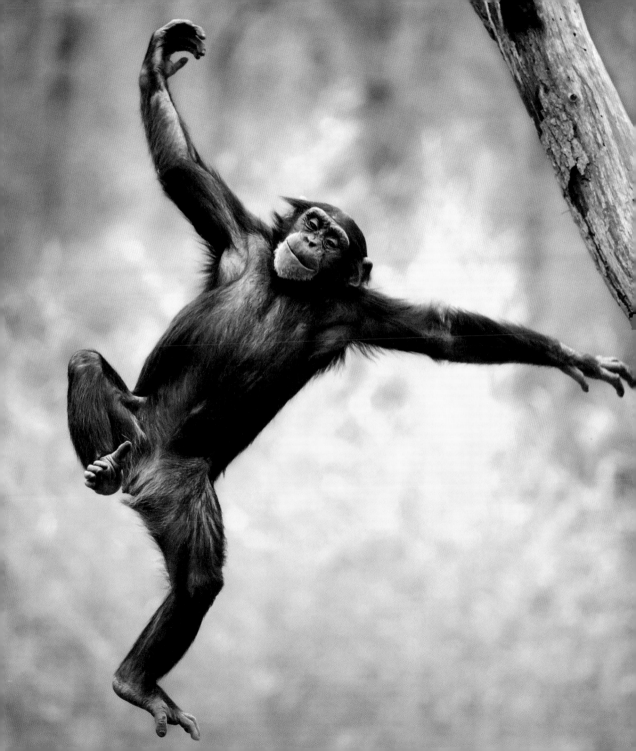

2
April

I can resist everything
except temptation.

– Oscar Wilde

3
April

At times it is difficult to make
the right choice, because you either feel
a prick of conscience or the pricks of hunger.

– Totò

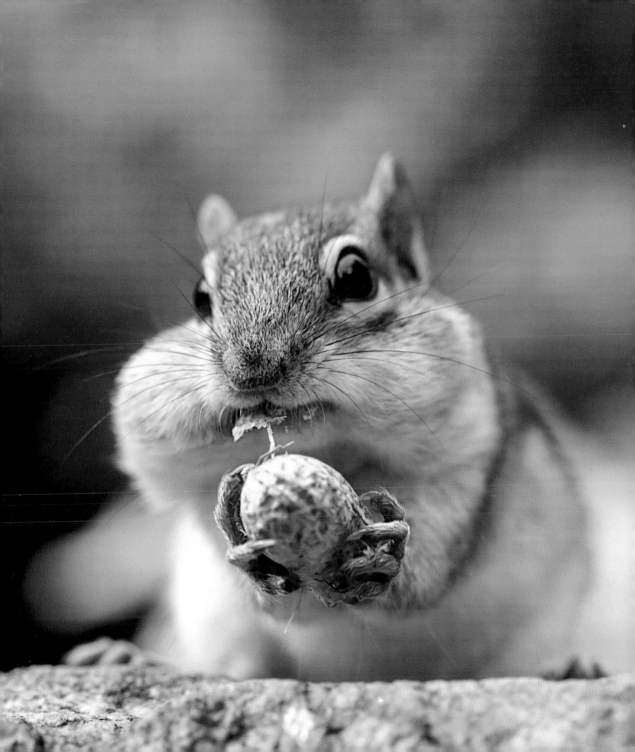

4

April

Law of the Bath: when the body is fully
immersed in water, the telephone rings.

– Murphy's Law

5

April

My doctor told me to stop
having intimate dinners for four.
Unless there are three other people.

– Orson Welles

6

April

Think of how stupid
the average person is, and realize
half of them are stupider than that.

– George Carlin

7
April

If you're going to do something tonight
that you'll be sorry for
tomorrow morning, sleep late.

– Henny Youngman

8
April

Sweater, n.: garment worn by child
when its mother is feeling chilly.

– Ambrose Bierce

9

April

Money can buy you
a fine dog, but only love
can make him wag his tail.

– Kinky Friedman

10

April

I'm plagued with indecision in my life.
I can't figure out what
to order in a restaurant.

– Chuck Close

11
April

I'd kiss a frog even if there was
no promise of a Prince Charming
popping out of it. I love frogs.

– Cameron Diaz

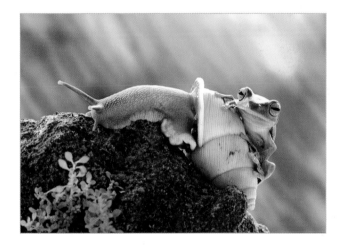

12
April

I suppose I'll have to add
the force of gravity
to my list of enemies.

– Lemony Snicket

13
April

Sense of humor is important
in life, not just in clothing.
How boring to live a life in beige.

– Jean Pigozzi

14
April

If opportunity
doesn't knock,
build a door.

– Milton Berle

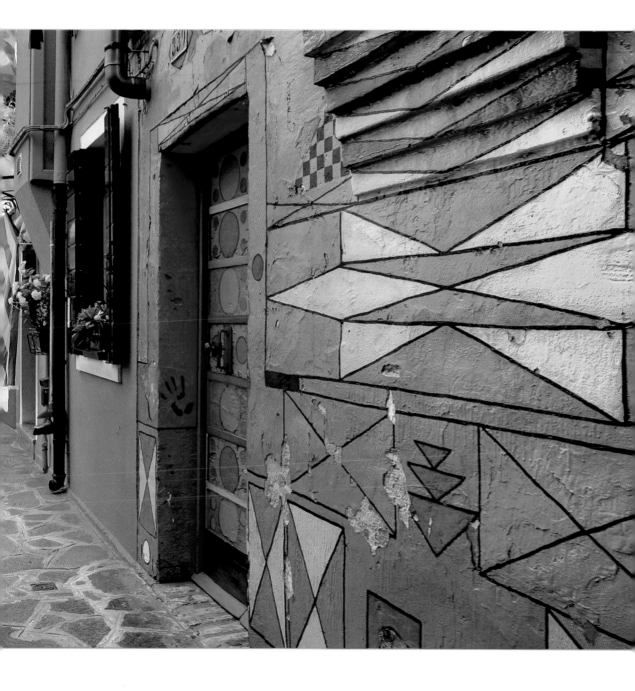

15

April

It's not what you look at
that matters, it's what you see.

– Henry David Thoreau

16

April

If I were two-faced,
would I be wearing this one?

– Abraham Lincoln

17

April

Life is a tragedy when seen in close-up,
but a comedy in long-shot.

– Charlie Chaplin

18
April

You can't look at a
sleeping cat and be tense.

– Jane Pauley

19
April

How many people here have telekinetic powers?
Raise my hand.

– Emo Philips

20
April

The guy who invented the first wheel was an idiot.
The guy who invented the other three, he was a genius.

– Sid Caesar

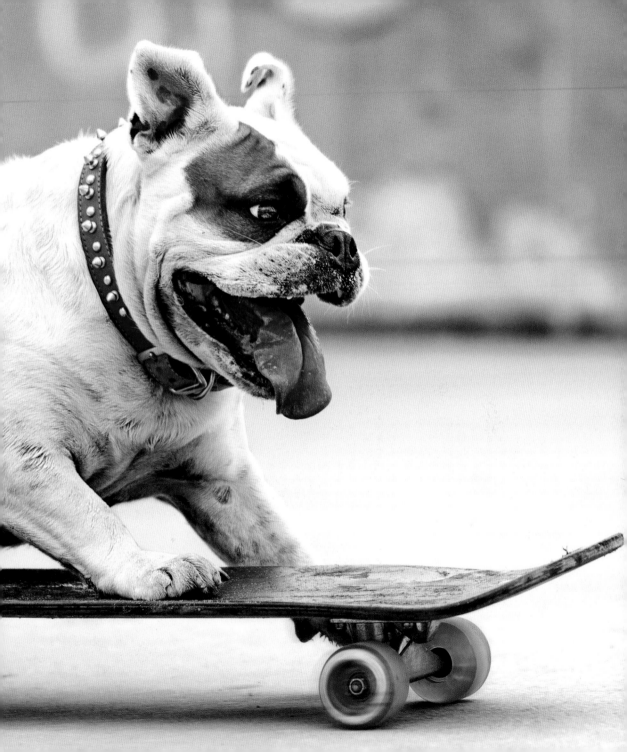

21
April

One morning, one of us
ran out of black, he used blue:
it was the birth of impressionism.

– Pierre-Auguste Renoir

22
April

You only live once, but if you
do it right, once is enough.

– Mae West

23

April

I like a woman with a head on her shoulders.
I hate necks.

– Steve Martin

24

April

The tongue is the only tool
that gets sharper with use.

– Washington Irving

25
April

An archaeologist is the best husband a woman can have;
the older she gets, the more interested he is in her.

– Agatha Christie

26
April

To me—old age is always
ten years older than I am.

– Bernard Baruch

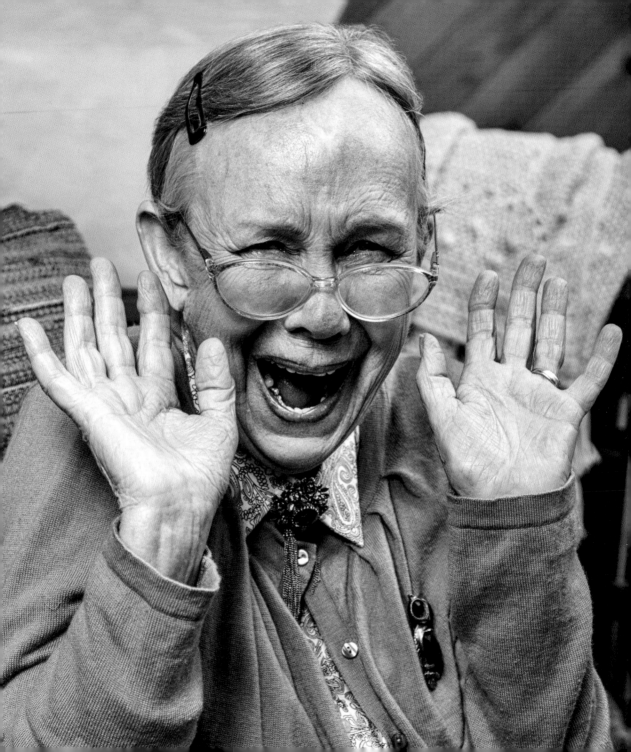

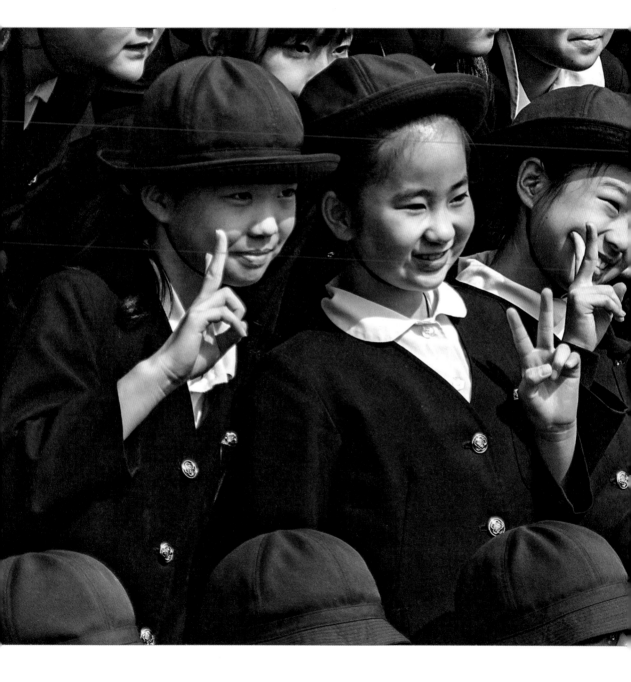

27
April

Always be nice to your children
because they are the ones
who will choose your rest home.

– Phyllis Diller

28
April

Sometimes I wish I had
a terrible childhood so that
at least I'd have an excuse.

– Jimmy Fallon

29
April

The problem with doing nothing is that
you never know when you're finished.

– Nelson DeMille

30
April

Procrastinate now,
don't put it off.

– Ellen DeGeneres

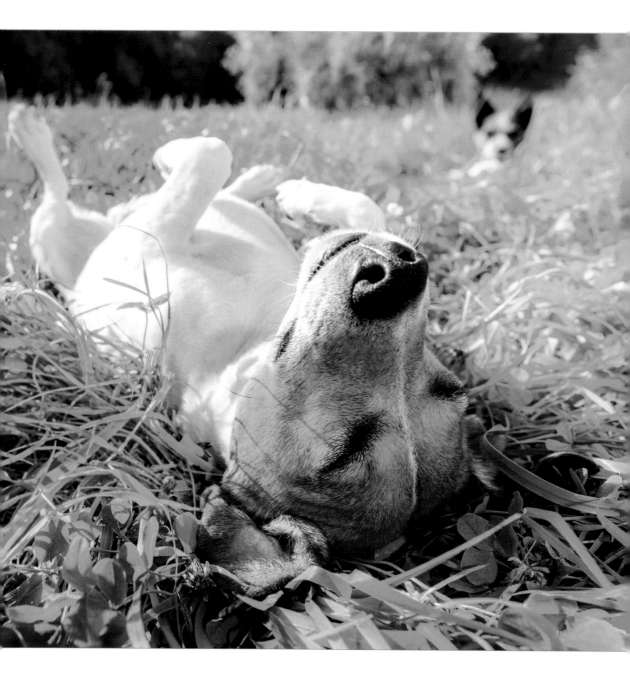

1

May

If I'm free, it's because
I'm always running.

– Jimi Hendrix

MAY

2

May

My little dog—
a heartbeat at my feet.

– Edith Wharton

3

May

You better cut the pizza in four pieces
because I'm not hungry enough to eat six.

– Yogi Berra

4

May

It is better to fail in originality
than to succeed in imitation.

– *Herman Melville*

5

May

When you think that you have all of the answers,
life changes all of the questions.

– *Charles M. Schulz*

6

May

I tell ya, my dog is lazy.
He don't chase cars.
He sits on the curb and
takes down license plate numbers.

– Rodney Dangerfield

7

May

My dog was my soul mate;
we both took naps,
we both skipped lunch,
we both hated the vacuum . . .

– Elayne Boosler

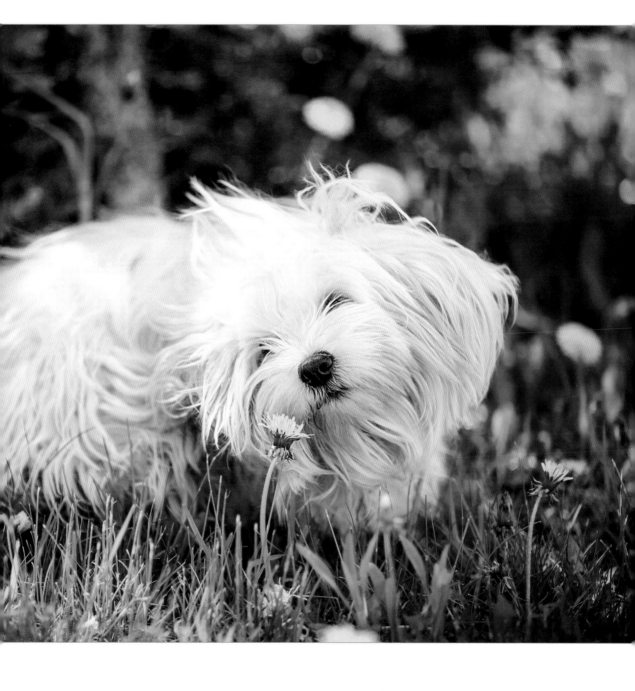

8

May

I'm sorry for the unkind words
I spoke out of hunger.

– Anonymous

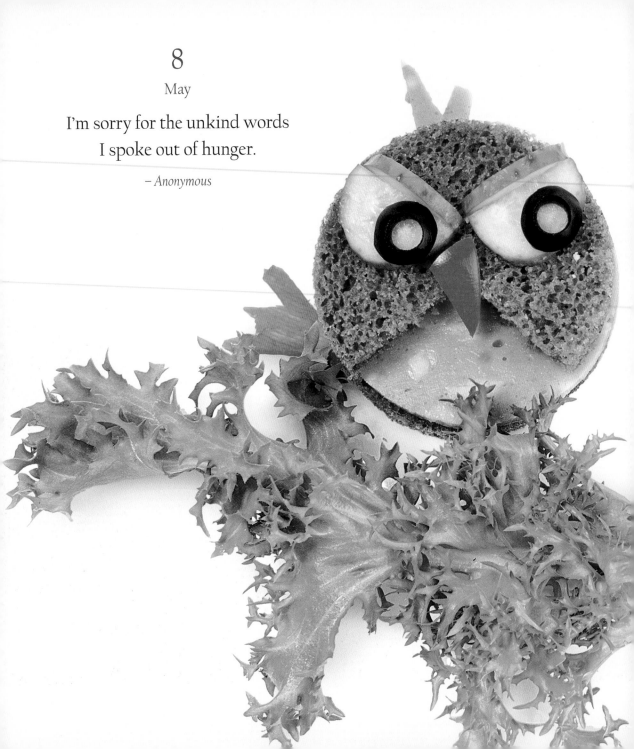

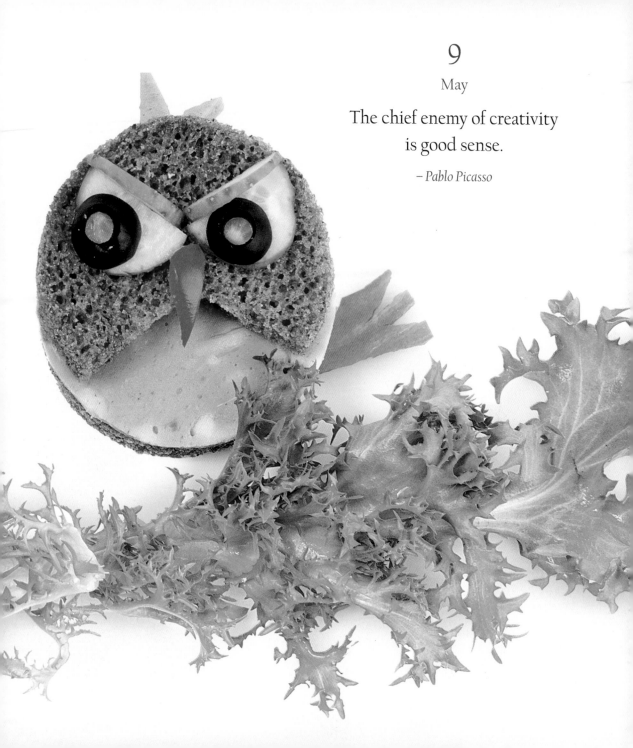

9
May

The chief enemy of creativity
is good sense.

– Pablo Picasso

10
May

Good painting is like good cooking;
it can be tasted, but not explained.

– Maurice de Vlaminck

11
May

This world is but a canvas
to our imagination.

– Henry David Thoreau

12
May

Creativity is allowing
yourself to make mistakes.
Art is knowing which ones to keep.

– Scott Adams

13

May

Don't look at me in that tone of voice.

– Dorothy Parker

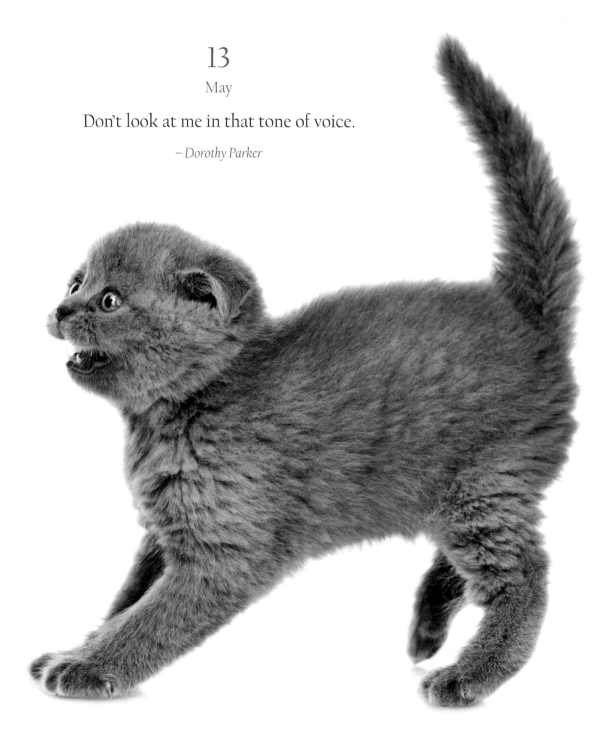

14

May

It is often said that before you die your life passes
before your eyes. It is in fact true. It's called living.

– *Terry Pratchett*

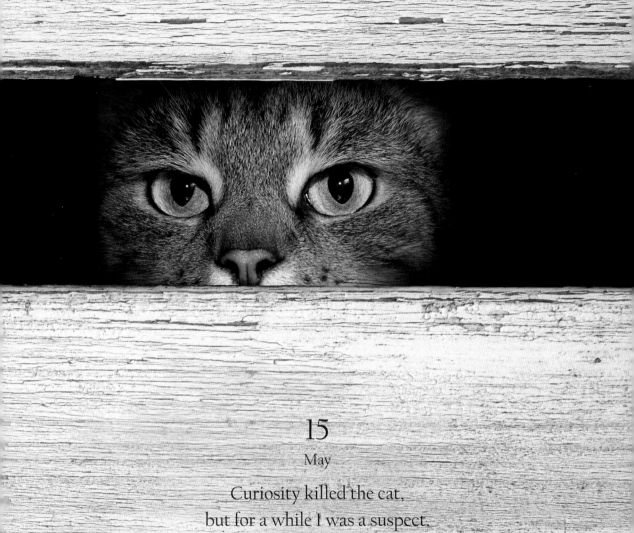

15

May

Curiosity killed the cat,
but for a while I was a suspect.

– *Steven Wright*

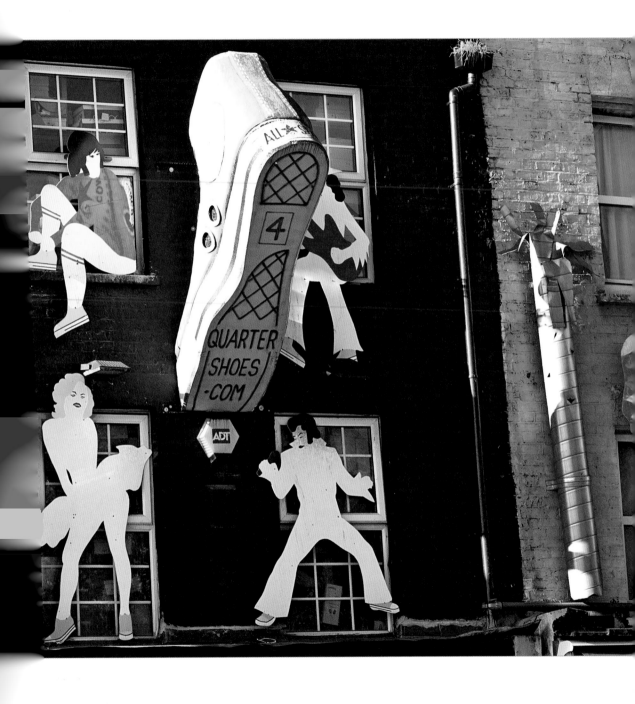

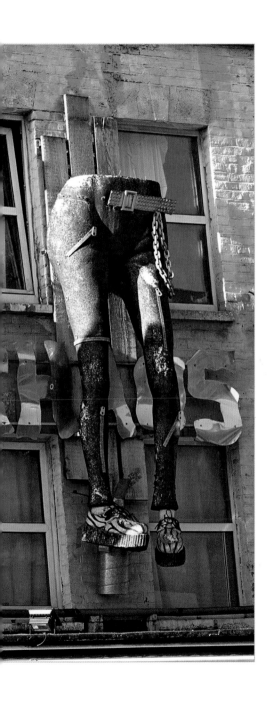

16
May

Shopping is a bit of a relaxing hobby
for me, which is sometimes
troubling for the bank balance.

– Rebecca Hall

17
May

A bargain is something
you don't need
at a price you can't resist.

– Franklin P. Jones

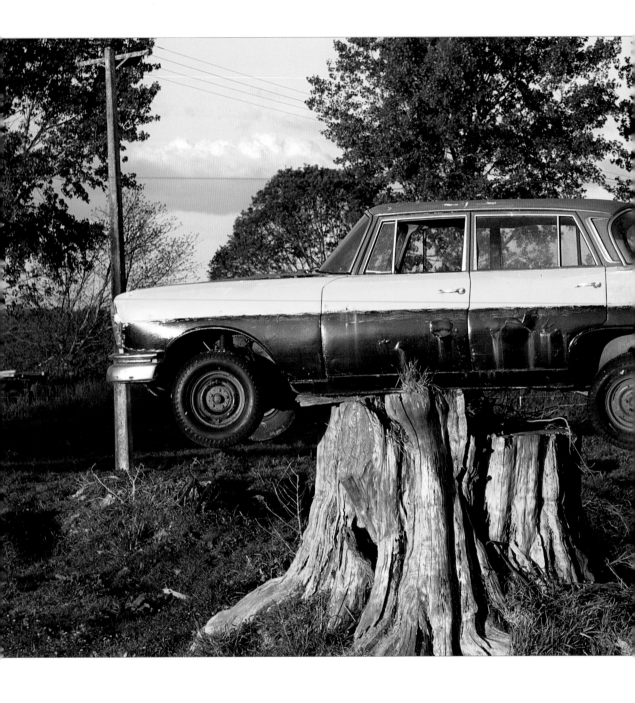

18

May

The best car safety device
is a rear-view mirror
with a cop in it.

– Dudley Moore

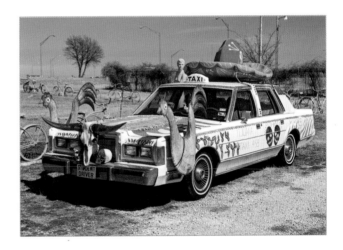

19

May

The artist is the one who knows
how to make an enigma out of a solution.

– Karl Kraus

20
May

Behind every great man
is a woman rolling her eyes.

– Jim Carrey

21
May

When I look into the future,
it's so bright it burns my eyes.

– Oprah Winfrey

22

May

If they don't give you a seat at the table,
bring a folding chair.

– Shirley Chisholm

23

May

Truth is always strange,
stranger than fiction.

– Lord Byron

24

May

If people never did silly things,
nothing intelligent would ever get done.

– *Ludwig Wittgenstein*

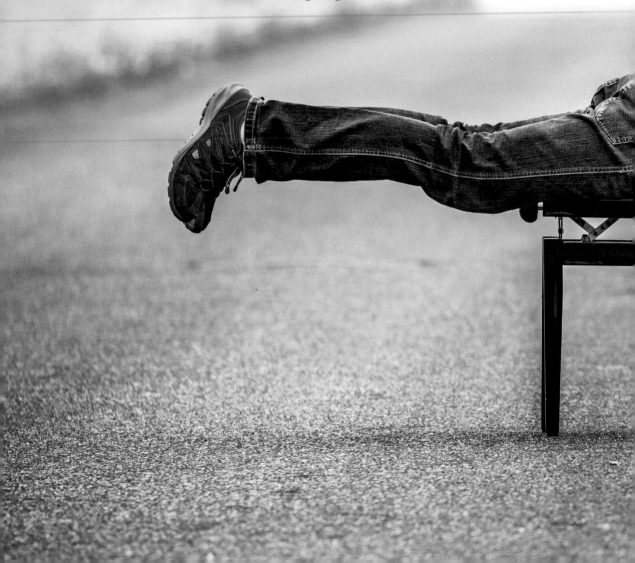

25

May

At a job interview, tell them you're willing to give 110 percent.
Unless the job is a statistician.

– Adam Gropman

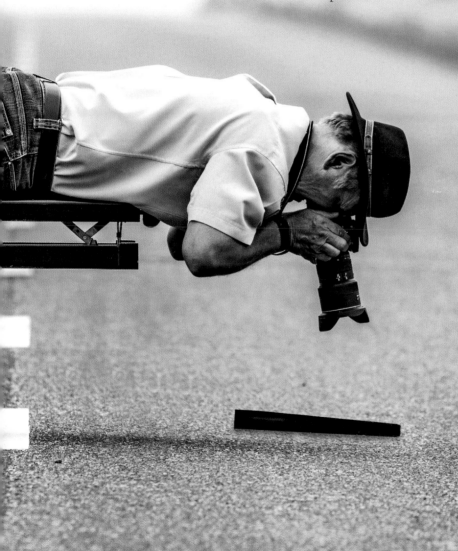

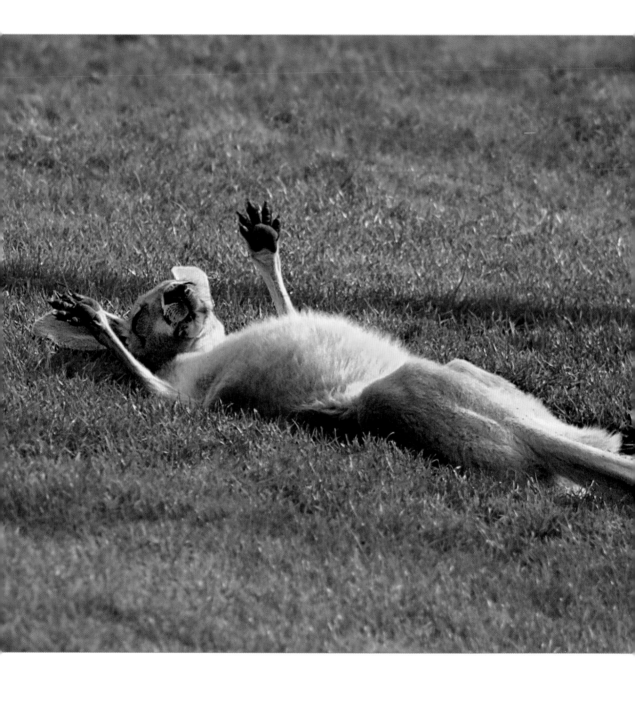

26
May

Though sleep is called
our best friend, it is a friend
who often keeps us waiting!

– Jules Verne

27
May

You know you're in love
when you can't fall asleep because reality
is finally better than your dreams.

– Dr. Seuss

28
May

Diversity: the art of thinking
independently together.

– *Malcolm Forbes*

29
May

A conference is a gathering of people
who singly can do nothing,
but together can decide
that nothing can be done.

– *Fred Allen*

30
May

Since we cannot change
reality, let us change
the eyes which see reality.

– Nikos Kazantzakis

31
May

I am hitting my head against the walls,
but the walls are giving way.

– Gustav Mahler

1

June

Both optimists and pessimists
contribute to society.
The optimist invents the airplane,
the pessimist the parachute.

– George Bernard Shaw

JUNE

2

June

You can cut all the flowers but
you cannot keep spring from coming.

– Pablo Neruda

3

June

If you think squash
is a competitive activity,
try flower arranging.

– Alan Bennett

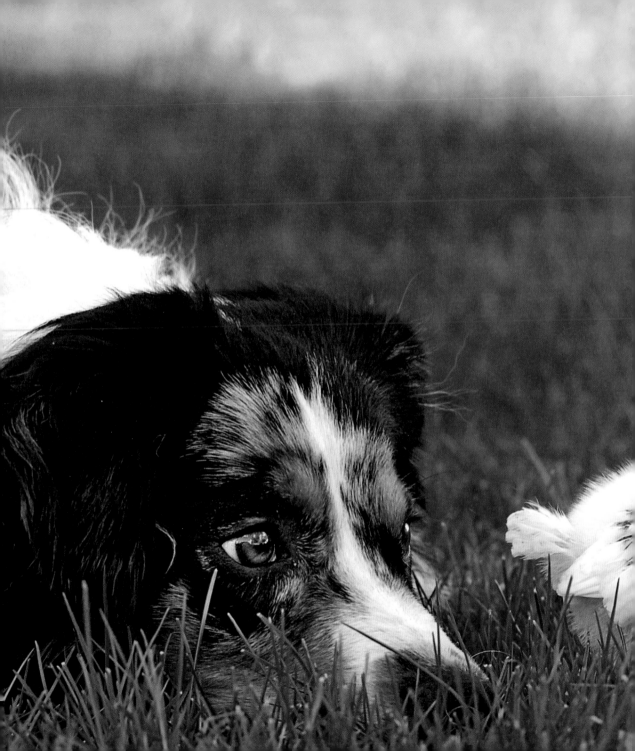

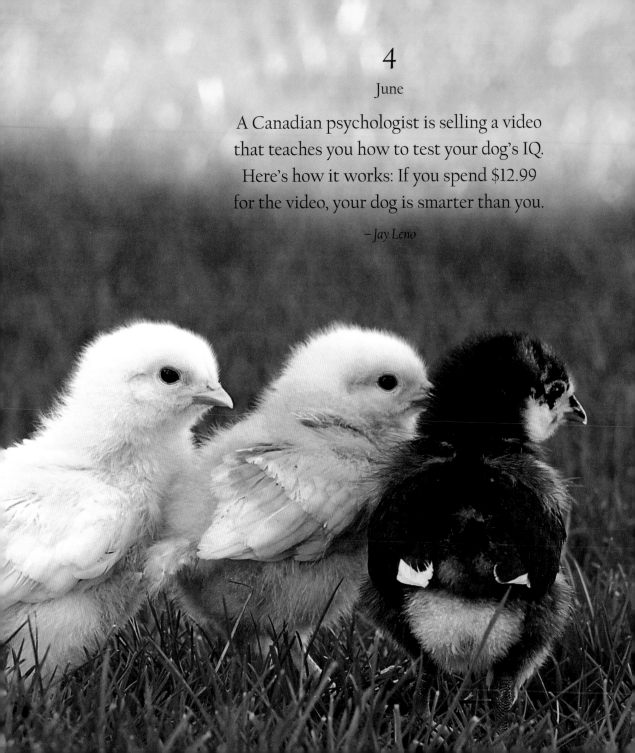

4

June

A Canadian psychologist is selling a video
that teaches you how to test your dog's IQ.
Here's how it works: If you spend $12.99
for the video, your dog is smarter than you.

– Jay Leno

5

June

Only in art will the lion lie down with
the lamb, and the rose grow without thorn.

– Martin Amis

6

June

Be a good listener. Your ears
will never get you in trouble.

– Frank Tyger

7

June

I told my doctor I get very tired when I go on a diet,
so he gave me pep pills. Know what happened? I ate faster.

– *Joe E. Lewis*

8

June

I've been on a diet for two weeks
and all I've lost is two weeks.

– Totie Fields

9

June

If the universe is expanding,
why can't I find a parking space?

– *Woody Allen*

10

June

Sometimes the road less traveled
is less traveled for a reason.

– *Jerry Seinfeld*

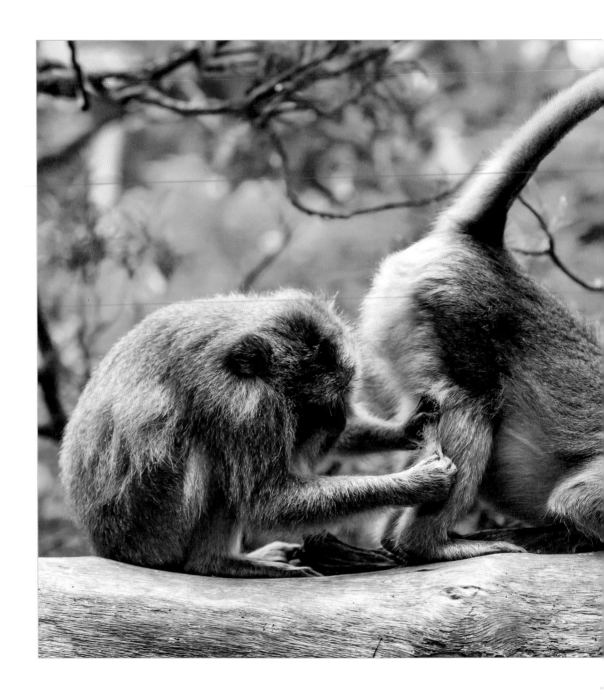

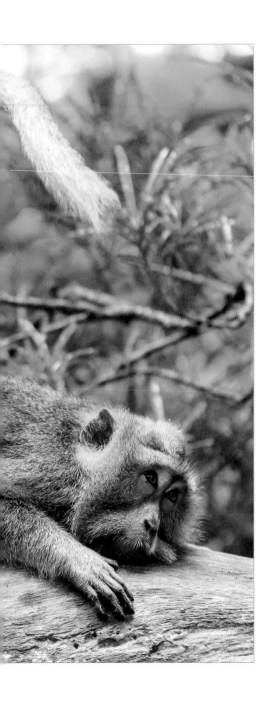

11
June

I learned the way a monkey learns—
by watching its parents.

– Charles, Prince of Wales

12
June

People talk too much.
Humans aren't descended from monkeys.
They come from parrots.

– Carlos Ruiz Zafón

13
June

When I was a kid I got no respect.
I played hide-and-seek.
They wouldn't even look for me.

– Rodney Dangerfield

14
June

Children find everything in nothing;
men find nothing in everything.

– Giacomo Leopardi

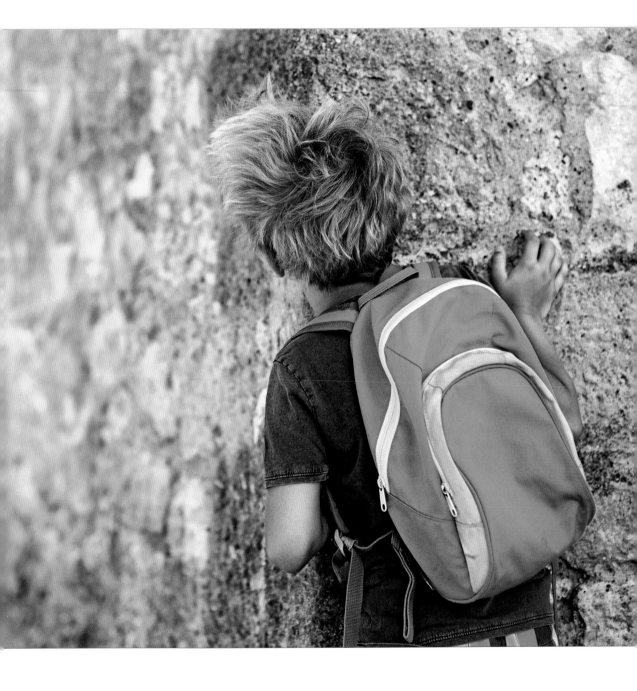

15

June

Half of seeming clever
is keeping your mouth shut
at the right times.

– Patrick Rothfuss

16

June

If two wrongs don't make a right,
try three.

– Laurence J. Peter

17

June

Cat: a pygmy lion who loves mice,
hates dogs, and patronizes human beings.

– Oliver Herford

18

June

Cats' hearing apparatus is built
to allow the human voice to easily
go in one ear and out the other.

– *Stephen Baker*

19

June

I grew up with six brothers.
That's how I learned to dance—
waiting for the bathroom.

– Bob Hope

20

June

The art of living is more
like wrestling than dancing.

– Marcus Aurelius

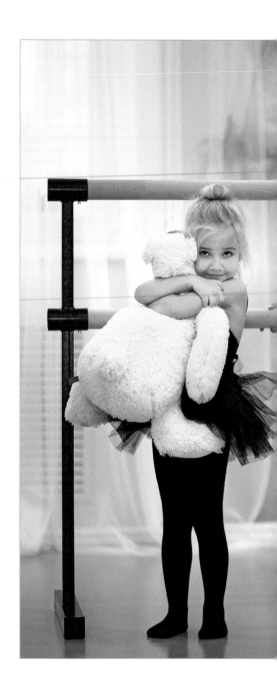

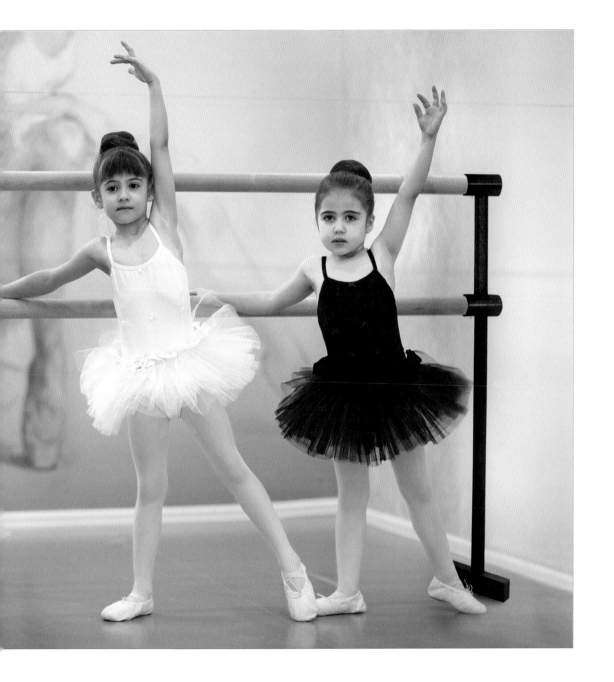

21
June

Reality continues
to ruin my life.

– Bill Watterson

22
June

Don't worry about failure;
you only have to be right once.

– Drew Houston

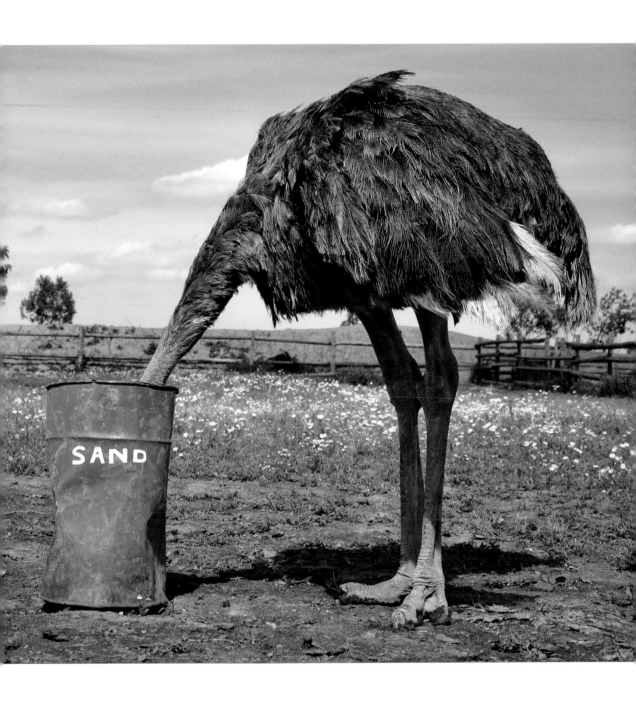

23

June

There's an unseen force which lets birds
know when you've just washed your car.

– Denis Norden

24

June

You found it offensive? I found it funny.
That's why I'm happier than you.

– Ricky Gervais

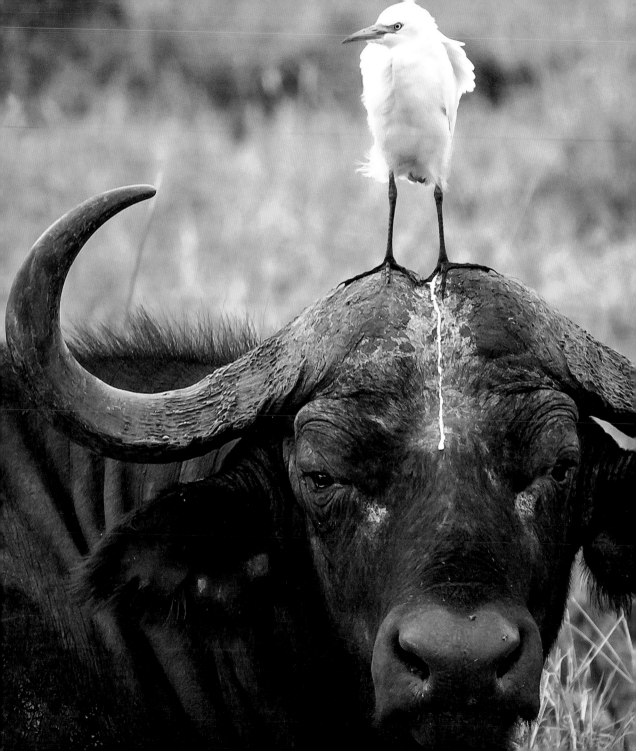

25

June

I like simple makeup.

– Arizona Muse

26

June

I have learned all kinds of things from my many mistakes. The one thing I never learn is to stop making them.

– Joe Abercrombie

27
June

Fate is like a strange, unpopular restaurant
filled with odd little waiters
who bring you things you never
asked for and don't always like.

– Lemony Snicket

28
June

I don't want to say we eat out a lot,
but I've noticed that lately
when I call my kids for dinner,
they run to the car.

– Julie Kidd

29
June

When you turn off the main road, you have to be prepared to see some funny houses.

– Stephen King

30
June

You can be a good neighbor
only if you have good neighbors.

– Howard E. Koch

1

July

I'm lazy, but it's the lazy people
who invented the wheel and the bicycle
because they didn't like walking
or carrying things.

– Lech Walesa

JULY

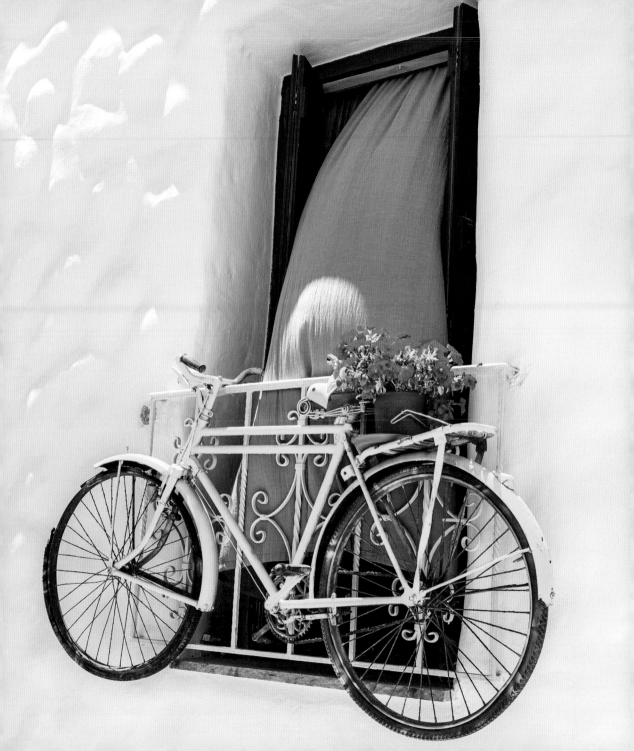

2
July

A man on the Moon will never be
as interesting as a woman under the Sun.

– Leopold Fechtner

3
July

They say we're 98% water.
We're that close to drowning.

– Steven Wright

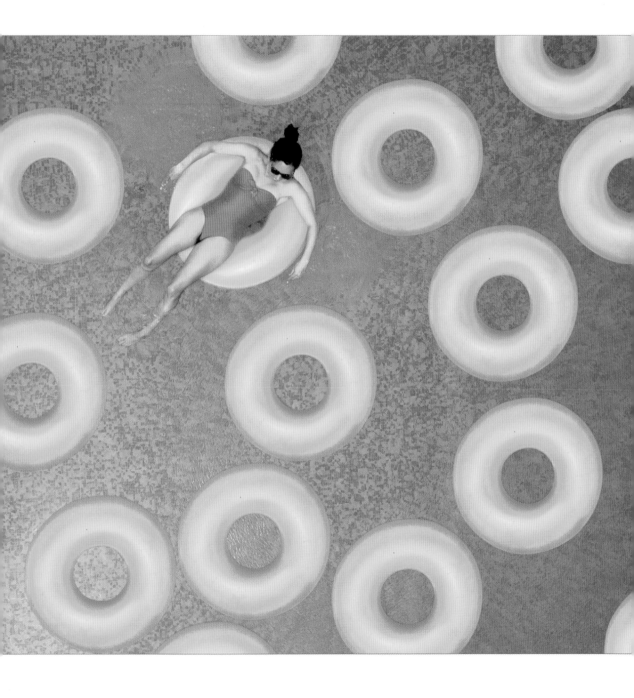

4

July

Children learn to smile
from their parents.

– Shinichi Suzuki

5

July

A loyal friend is worth
ten thousand relatives.

– Euripides

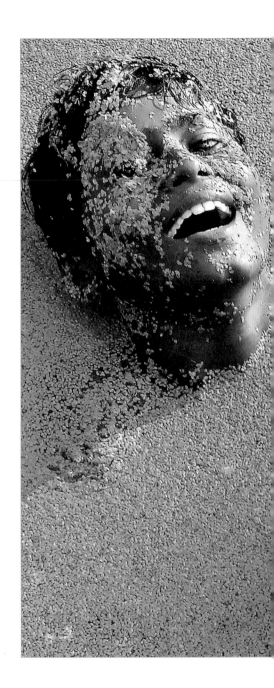

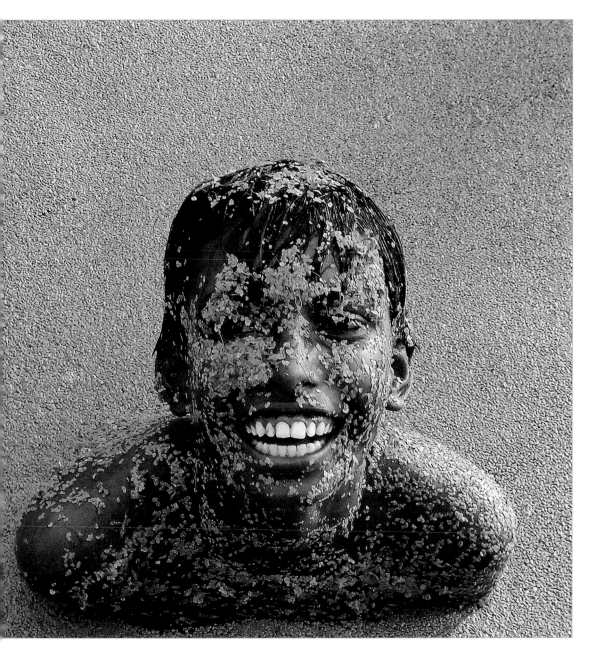

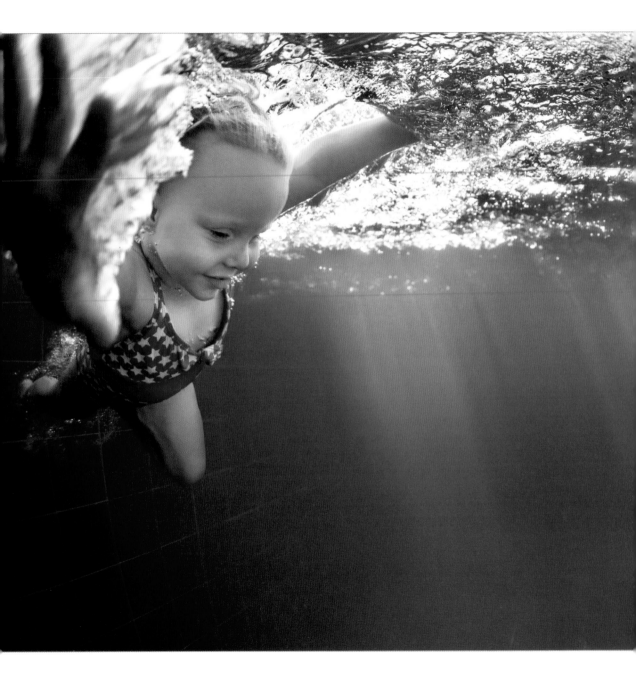

6

July

All good writing is swimming
under water and holding your breath.

– Francis Scott Fitzgerald

7

July

You know when you put a stick
in water and it looks bent?
That's why I never take baths.

– Steven Wright

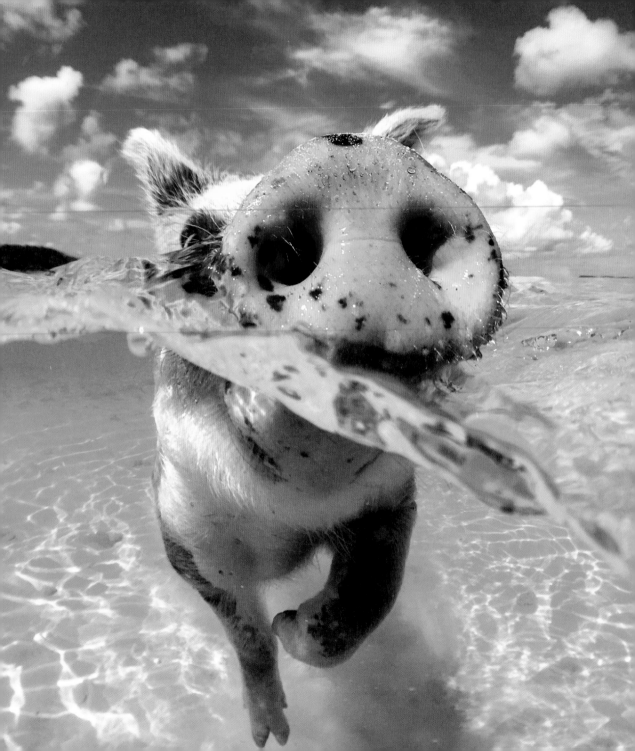

8

July

I learned long ago, never to wrestle with a pig.
You get dirty, and besides, the pig likes it.

– George Bernard Shaw

9

July

I don't let myself "surf" on the Web,
or I would probably drown.

– Aubrey Plaza

10

July

I always have trouble remembering three things:
faces, names, and . . . I can't remember what the third thing is.

– Fred Allen

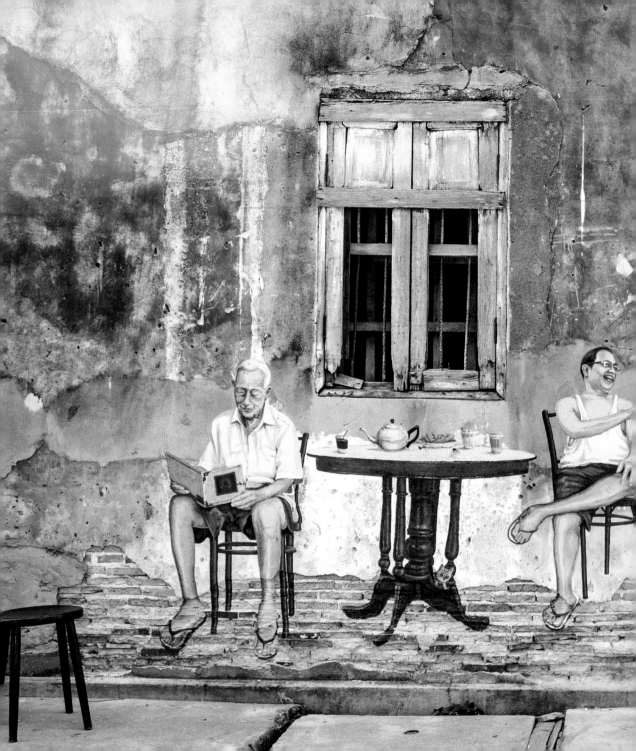

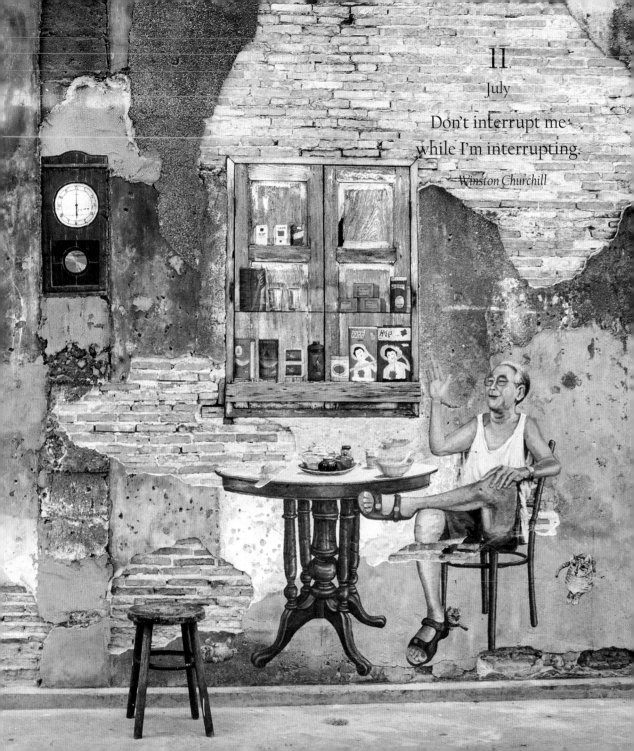

July

Don't interrupt me
while I'm interrupting.

~ Winston Churchill

12

July

Whenever the competition is sleeping
is when I shine.

– Kim Collins

13

July

My best fiction writing
is my daily to-do list.

– *Anonymous*

14
July

In youth we learn;
in age we understand.

– Marie von Ebner-Eschenbach

15
July

I always wanted to be somebody,
but now I realize I should
have been more specific.

– Lily Tomlin

16
July

After all, the wool of a black sheep
is just as warm.

– Ernest Lehman

17
July

Don't talk about yourself;
it will be done when you leave.

– Wilson Mizner

18
July

People love cycling
but hate cyclists.

– Peter Zanzottera

19
July

I do not pray for a lighter load,
but for a stronger back.

– Phillips Brooks

20

July

My favorite way to blow off steam
is to sing obnoxiously loud in the shower.

– Chris Pratt

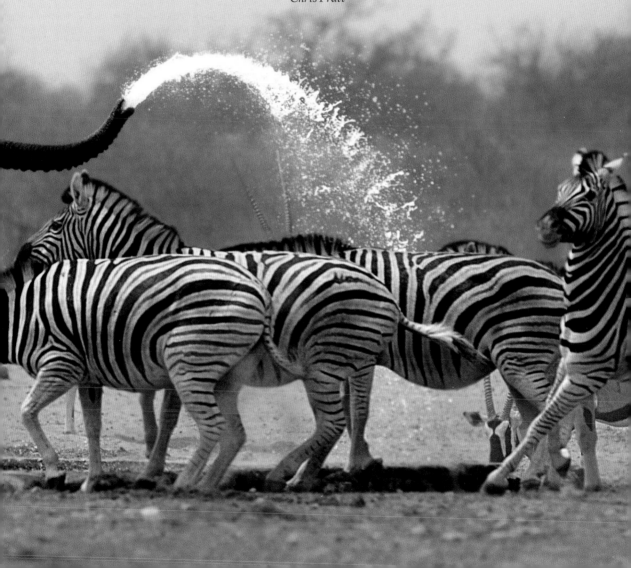

21
July

Art is a visual language;
I'm just perfecting my alphabet.

– Zachary A. Diaz

22
July

Never underestimate a child's ability
to get into more trouble.

– Martin Mull

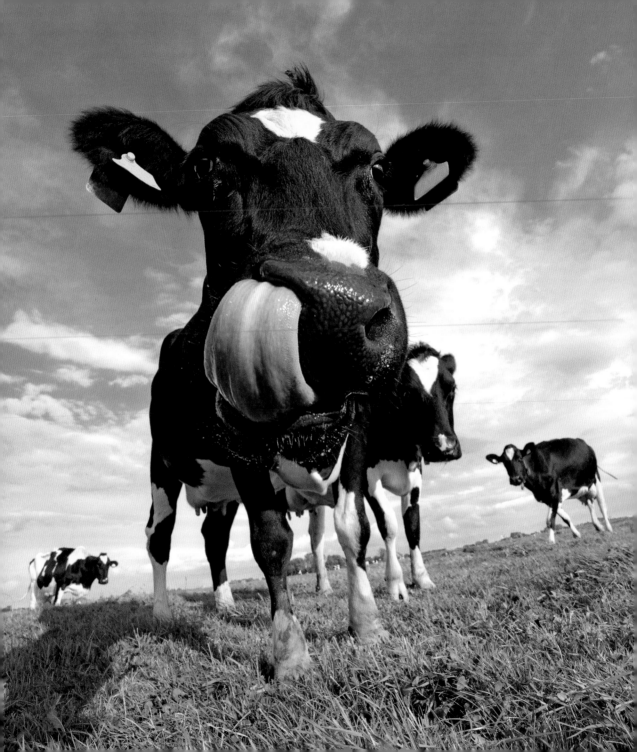

23

July

The first law of dietetics seems to be:
if it tastes good, it's bad for you.

– Isaac Asimov

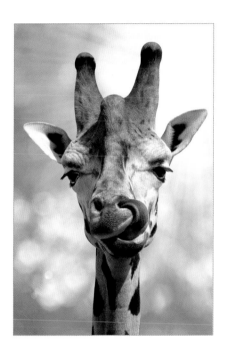

24

July

I am not a glutton—I am an explorer of food.

– Erma Bombeck

25
July

You could cover the whole earth with
asphalt, but sooner or later
green grass would break through.

– Ilya Ehrenburg

26
July

The greater the obstacle,
the more glory in overcoming it.

– Molière

27
July

Look at the small things,
because one day you'll turn back
and you'll understand they were big.

– Jim Morrison

28
July

To see what is in front of one's nose
needs a constant struggle.

– George Orwell

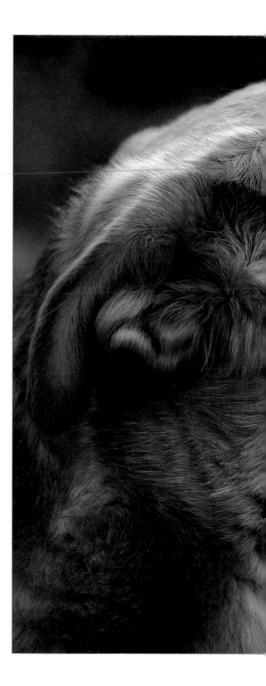

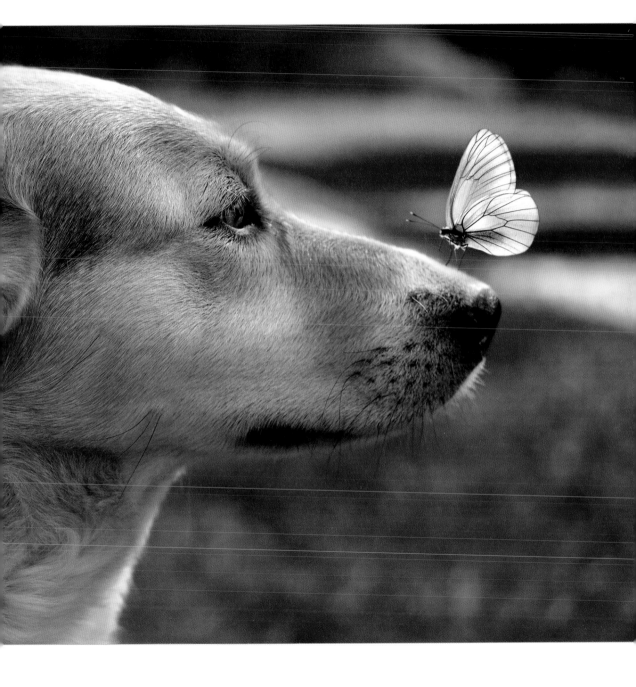

29
July

In matters of style, swim with the current;
in matters of principle, stand like a rock.

– Thomas Jefferson

30
July

I always arrive late at the office,
but I make up for it by leaving early.

– Charles Lamb

31
July

Dad was a passionate sailor,
and he taught me.

– Dorothy Atkinson

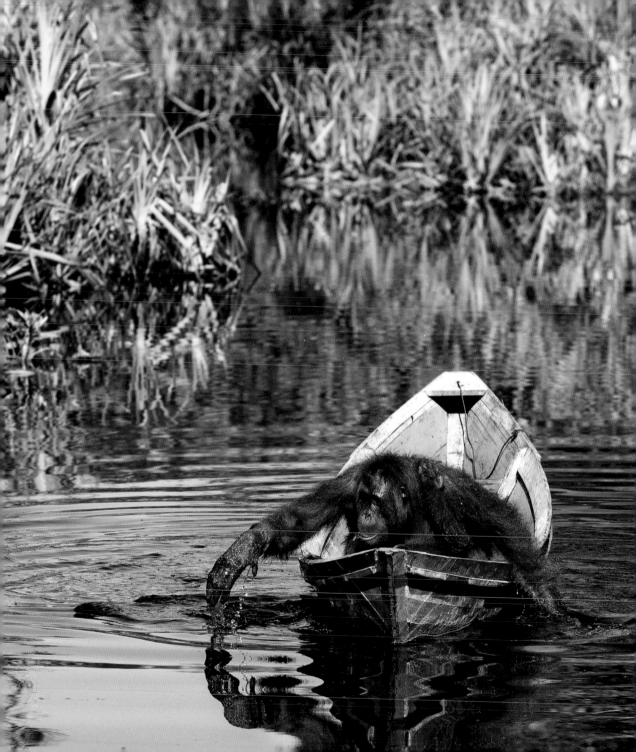

1

August

Do the difficult things
while they are easy
and do the great things
while they are small.
A journey of a thousand
miles must begin with
a single step.

– Laozi

AUGUST

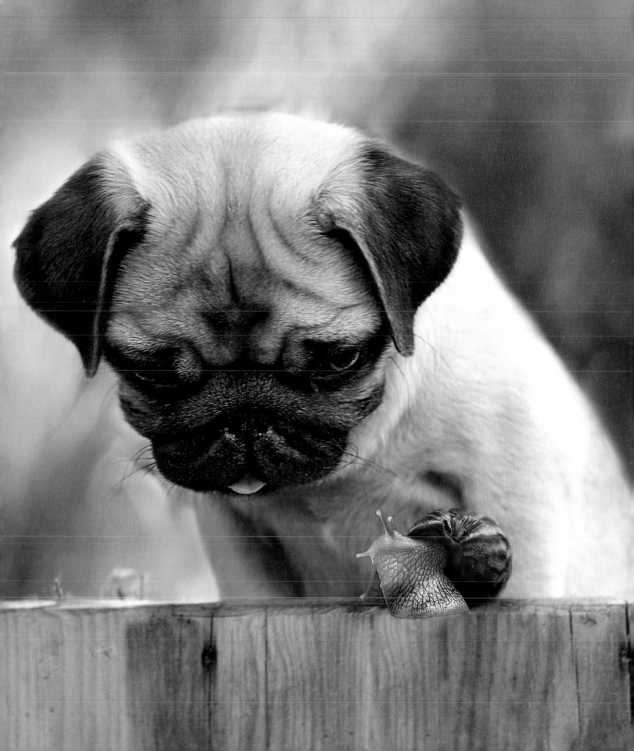

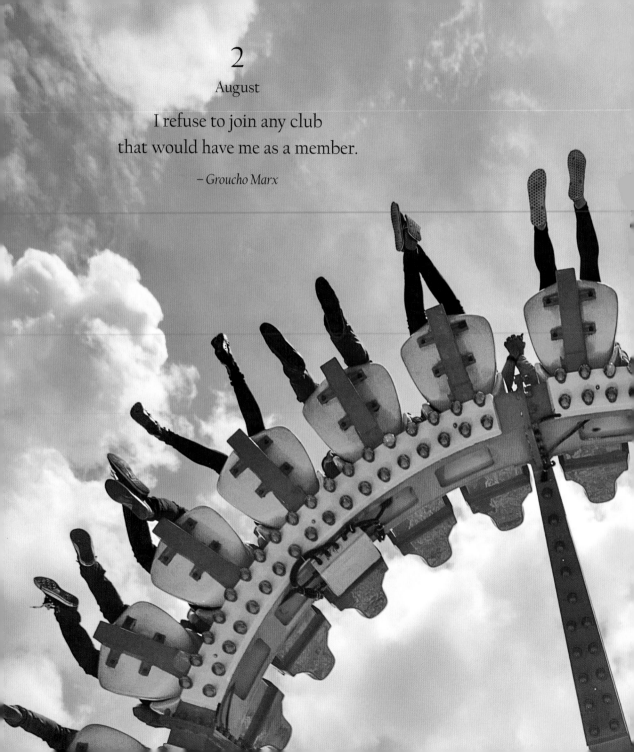

2

August

I refuse to join any club
that would have me as a member.

– Groucho Marx

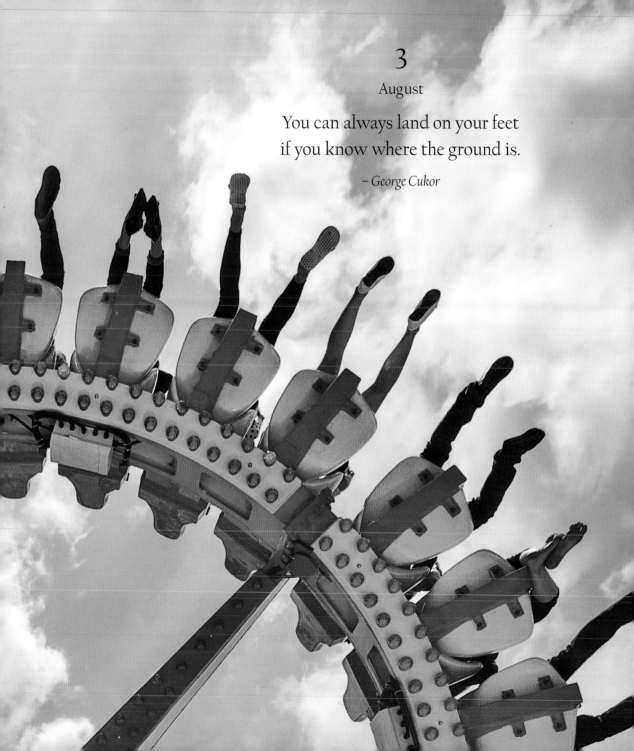

3

August

You can always land on your feet
if you know where the ground is.

– *George Cukor*

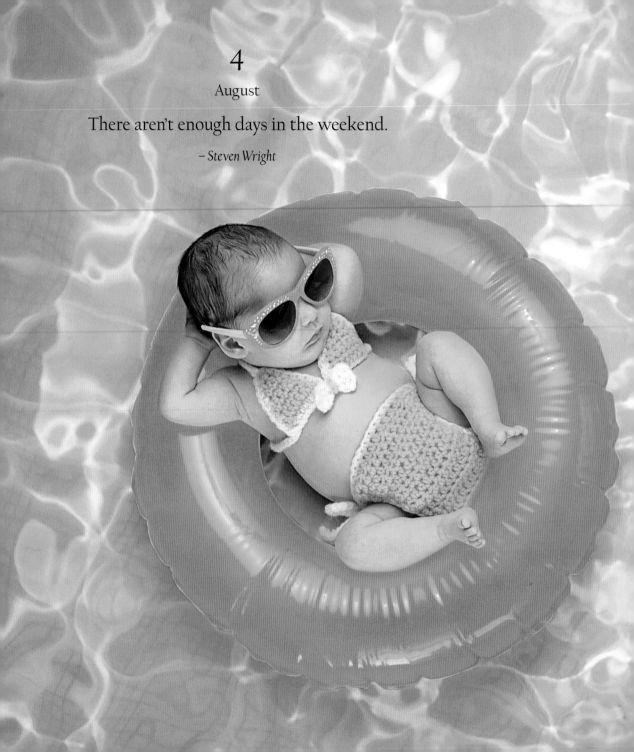

4
August

There aren't enough days in the weekend.

– *Steven Wright*

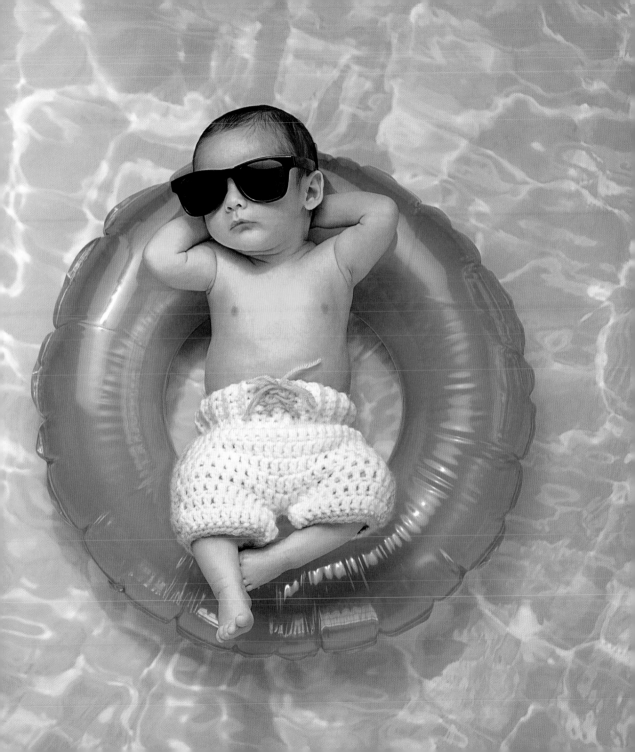

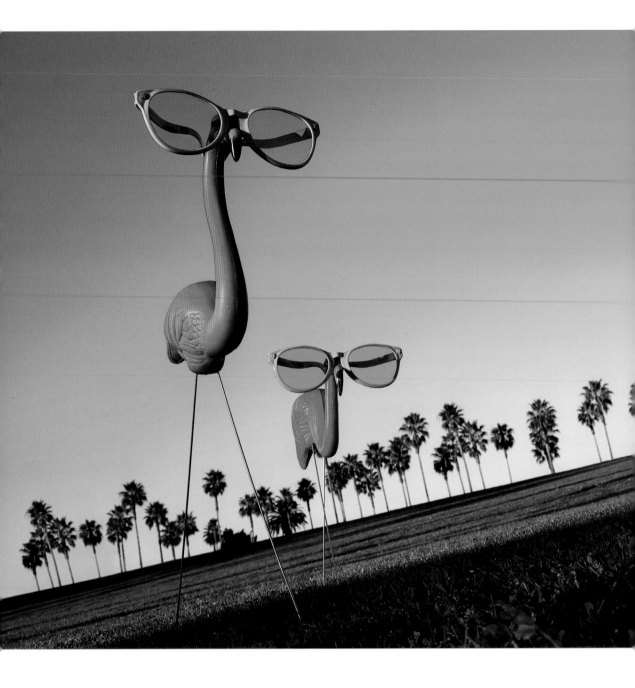

5

August

I can't think
without my glasses.

– *Vivienne Westwood*

6

August

Do not expect the world to look bright,
if you wear gray-brown glasses.

– *Charles William Eliot*

7

August

When you can't figure out what to do,
it's time for a nap.

– *Mason Cooley*

8

August

Nothing is so contagious
as enthusiasm.

– Samuel Taylor Coleridge

9

August

Be happy, and even if happiness
sometimes forgets about you,
don't forget about happiness.

– Roberto Benigni

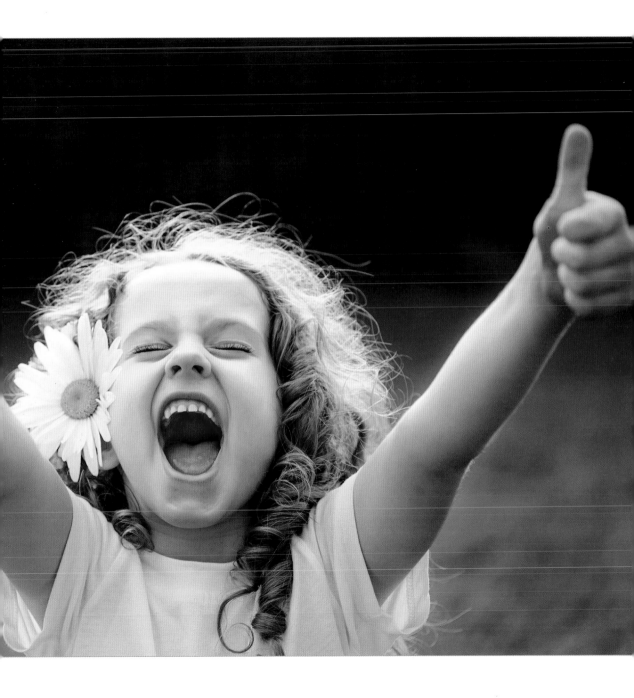

10

August

I haven't slept for ten days,
because that would be too long.

– Mitch Hedberg

11

August

Learn from yesterday,
live for today, look to tomorrow,
rest this afternoon.

– Charles M. Schulz

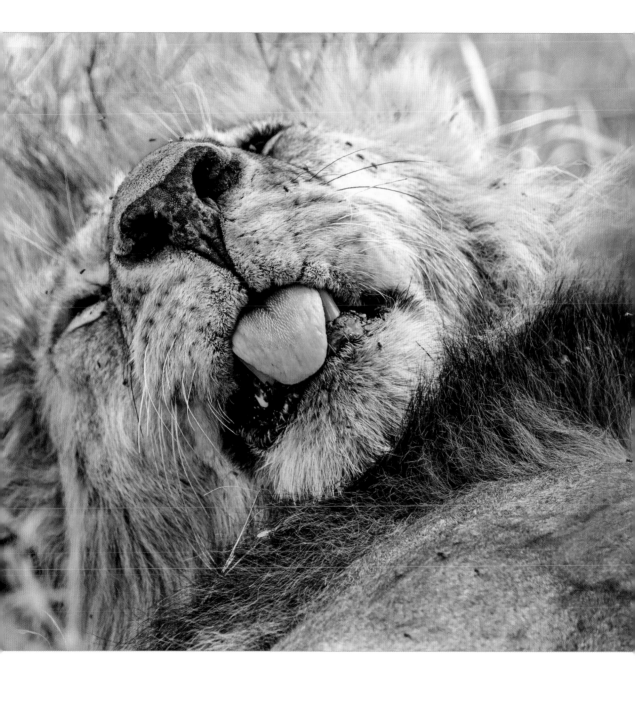

12
August

To invent, you need
a good imagination
and a pile of junk.

– Thomas A. Edison

13
August

If you only have a hammer,
you tend to see every
problem as a nail.

– Abraham Maslow

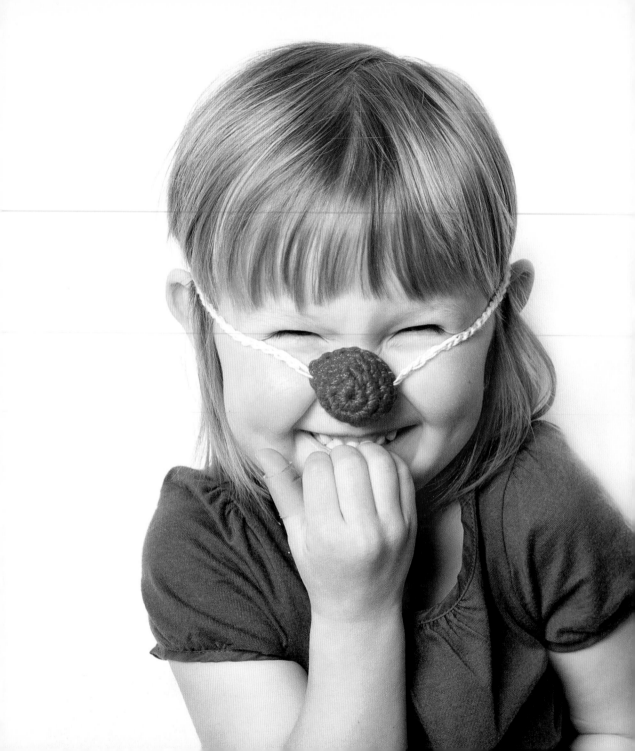

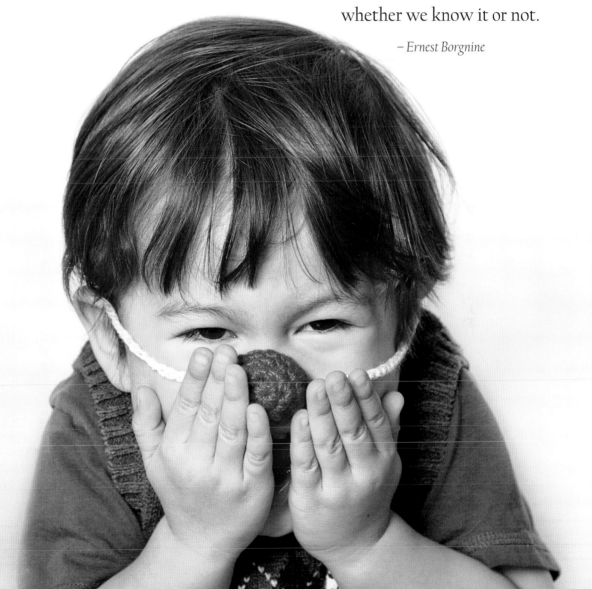

14
August

I think we all have
the urge to be a clown,
whether we know it or not.

– *Ernest Borgnine*

15

August

Eat, sleep and swim—
that's all I can do.

– Michael Phelps

16

August

Being happy
never goes out of style.

– Lilly Pulitzer

17

August

In three words I can sum up everything
I've learned about life: it goes on.

– Robert Lee Frost

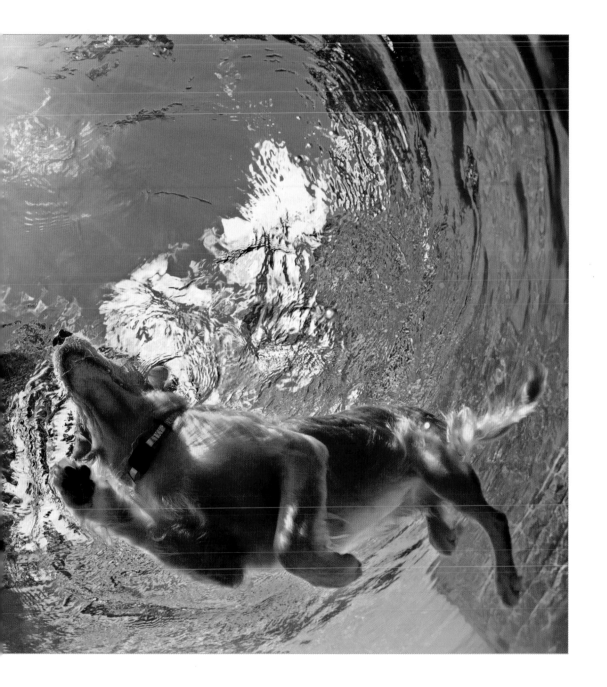

18

August

Drive slow and enjoy the scenery—
drive fast and join the scenery.

– Douglas Horton

19

August

Maturity is the slowness
in which a man believes.

– Baltasar Gracián

20

August

In philosophy if you aren't moving at
a snail's pace you aren't moving at all.

– Iris Murdoch

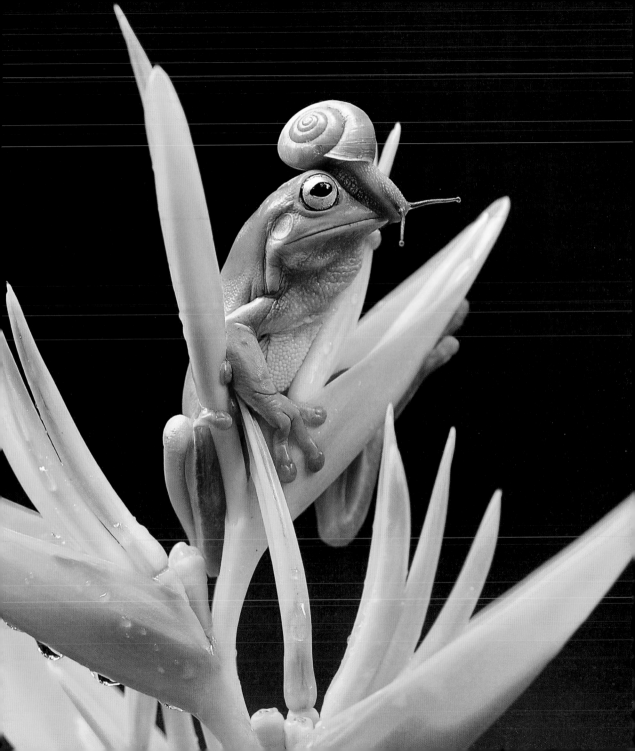

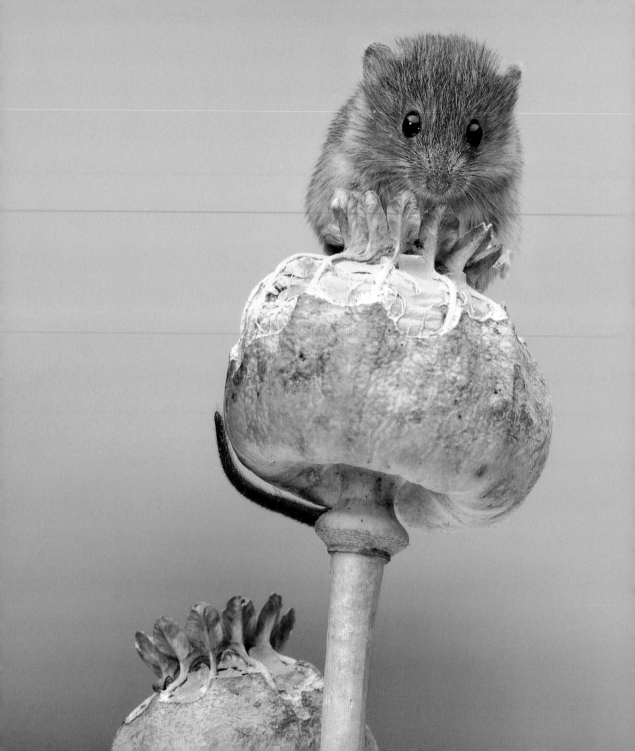

21

August

The universe is a big place,
perhaps the biggest.

– Kurt Vonnegut Jr.

22

August

I can always tell when
the mother-in-law's coming to stay;
the mice throw themselves on the traps.

– Les Dawson

23

August

Women and cats will do as they please,
and men and dogs should
relax and get used to the idea.

– Robert A. Heinlein

24

August

Nothing you wear is
more important than your smile.

– Connie Stevens

25

August

A yawn is
a silent shout.

– Gilbert K. Chesterton

26

August

Every dog is a lion at home.

– Henry George Bohn

27
August

The only exercise I excel at
is jumping to conclusions.

– James Northey Miller

28
August

People who say they sleep like
a baby usually don't have one.

– Leo J. Burke

29
August

We don't stop playing
because we grow old; we grow old
because we stop playing.

– George Bernard Shaw

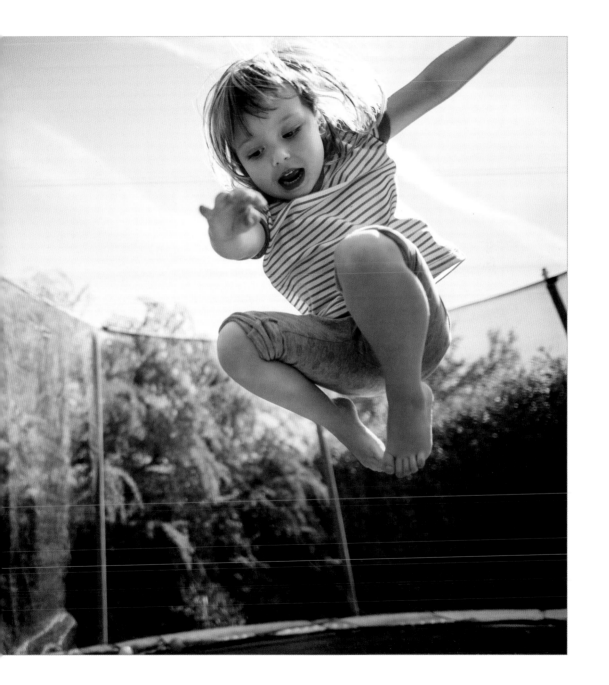

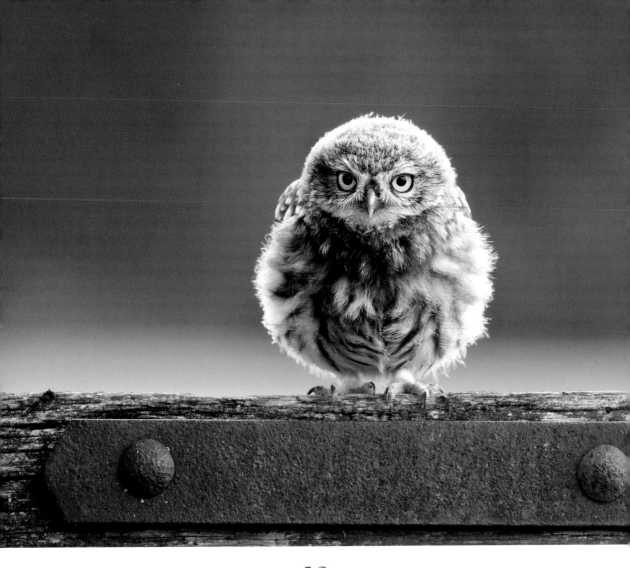

30

August

Everything has its beauty,
but not everyone sees it.

– Andy Warhol

31

August

If you think you are too small to be effective,
you have never been in the dark with a mosquito.

– Betty Reese

1

September

I think the reason I choose
the comic approach so often
is because it's harder, therefore affording
me the opportunity to show off.

– Rita Mae Brown

SEPTEMBER

2

September

Scratch a dog and you'll find
a permanent job.

– Franklin P. Jones

3

September

My idea of an agreeable person
is a person who agrees with me.

– Benjamin Disraeli

4

September

Being a mom has made me
so tired. And so happy.

– Tina Fey

5

September

I have three kids and a cat
and a busy, noisy house. I get more
time to relax when I'm working.

– Noel Gallagher

6

September

The four most beautiful words
in our common language: I told you so.

– Gore Vidal

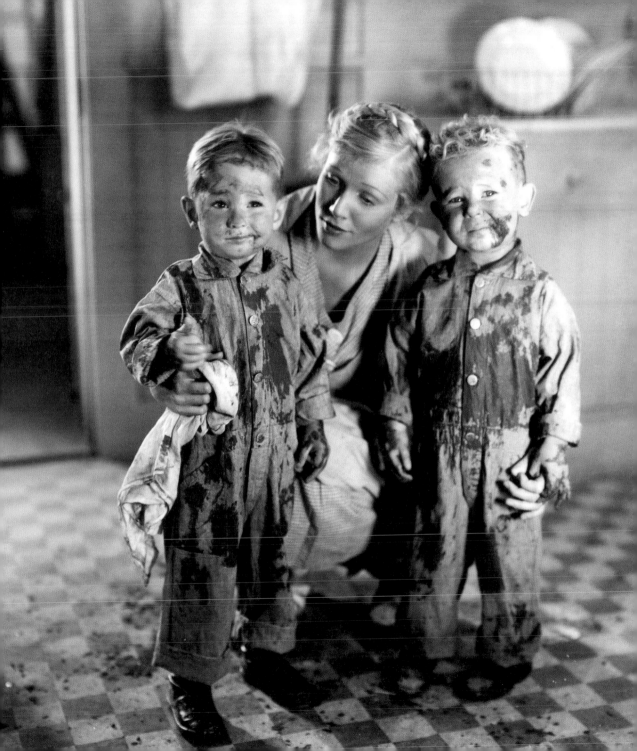

7
September

I don't focus on what I'm up against.
I focus on my goals
and I try to ignore the rest.

– Venus Williams

8
September

Believe me, for certain men at least,
not taking what one doesn't desire
is the hardest thing in the world.

– Albert Camus

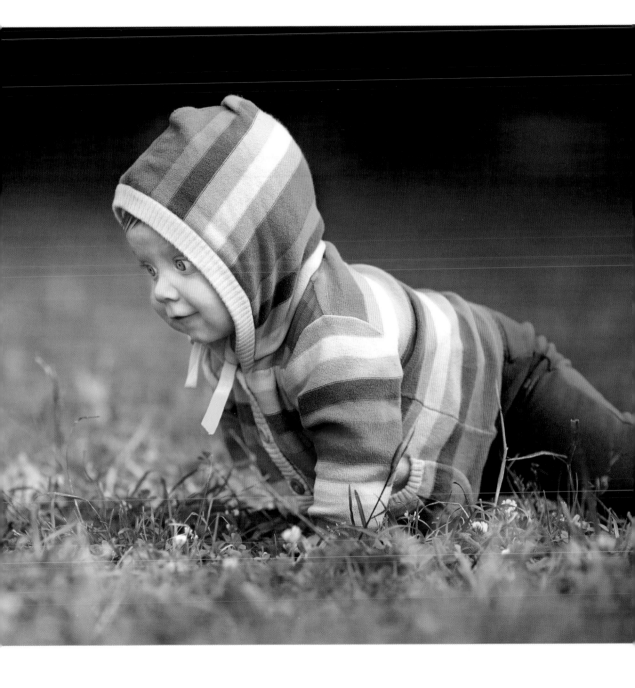

9

September

Never insult an alligator
until after you have crossed the river.

– Cordell Hull

10

September

Pretending that danger does not exist
is the best way to fall into it.

– Alain Rey

11

September

An animal's eyes have the power
to speak a great language.

– Martin Buber

12

September

Don't cry over spilled milk.
By this time tomorrow, it'll be free yogurt.

– Stephen Colbert

13
September

The trick is growing up
without growing old.

– Casey Stengel

14
September

I'm happy to report
that my inner child
is still ageless.

– James Broughton

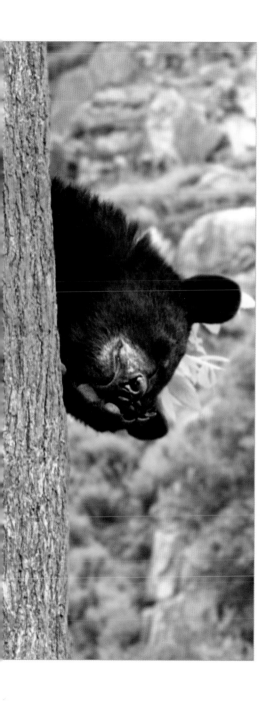

15
September

The amount of sleep
required by the average person
is five minutes more.

– Wilson Mizner

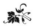

16
September

A day without a nap
is like a cupcake without frosting.

– Terri Guillemets

17

September

Natural beauty takes at least
two hours in front of a mirror.

– Pamela Anderson

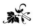

18

September

Saying "Do whatever you want"
to your hairdresser is a bit like
deciding to go bungee jumping
without the elastic cord.

– Luciana Littizzetto

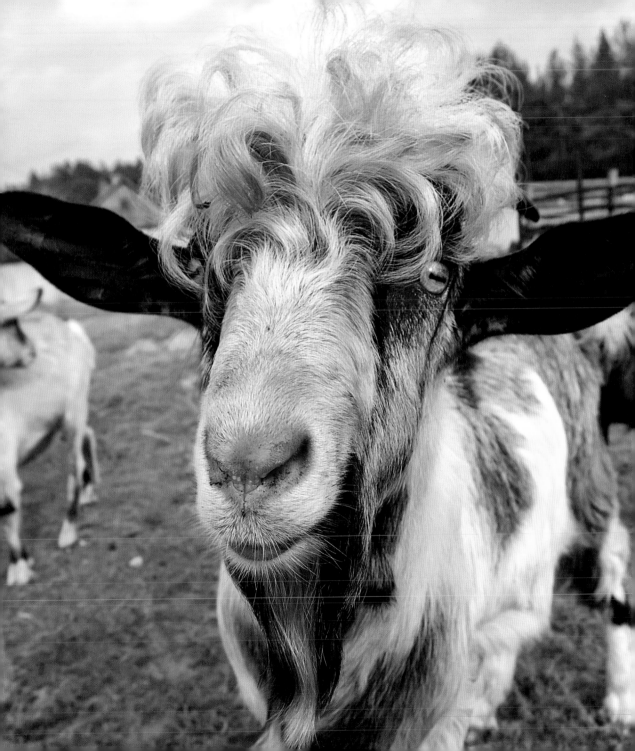

19

September

I like nonsense;
it wakes up the brain cells.

– Dr. Seuss

20

September

A woman without a man
is like a fish without a bicycle.

– Gloria Steinem

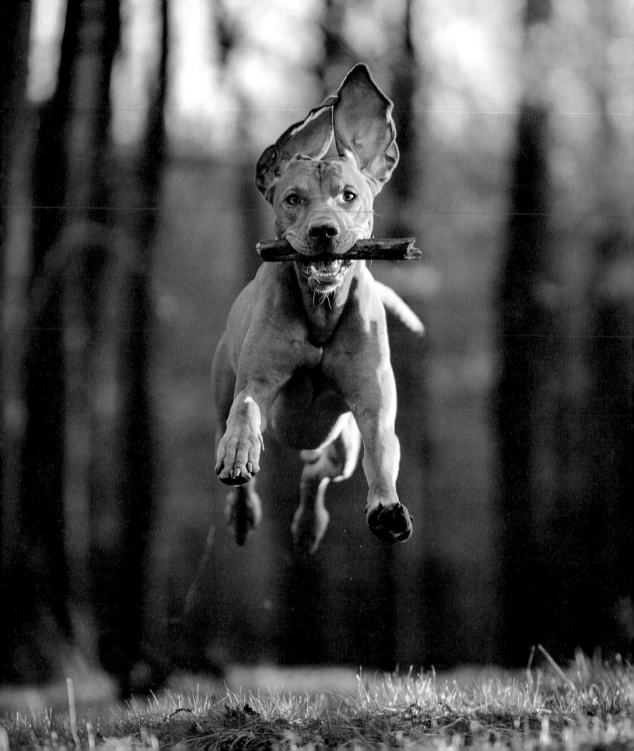

21

September

When your children are teenagers,
it's important to have a dog so that
someone in the house is happy to see you.

– Nora Ephron

22

September

My doctor told me my jogging could add
years to my life. In effect, when I run
I look ten years older.

– Lee Trevino

23

September

Dogs have boundless
enthusiasm but no sense of shame.
I should have a dog as a life coach.

– Moby

24

September

Eagles are seagulls
with a good hairdo.

– Douglas Coupland

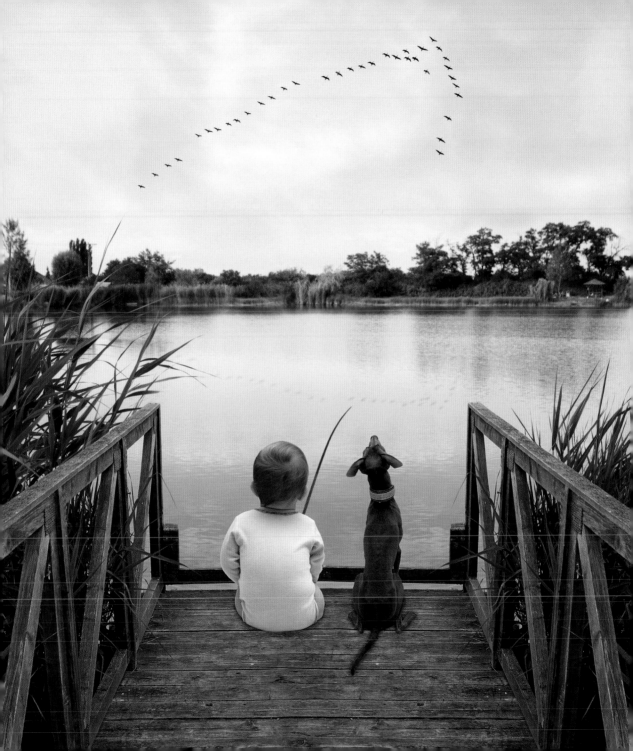

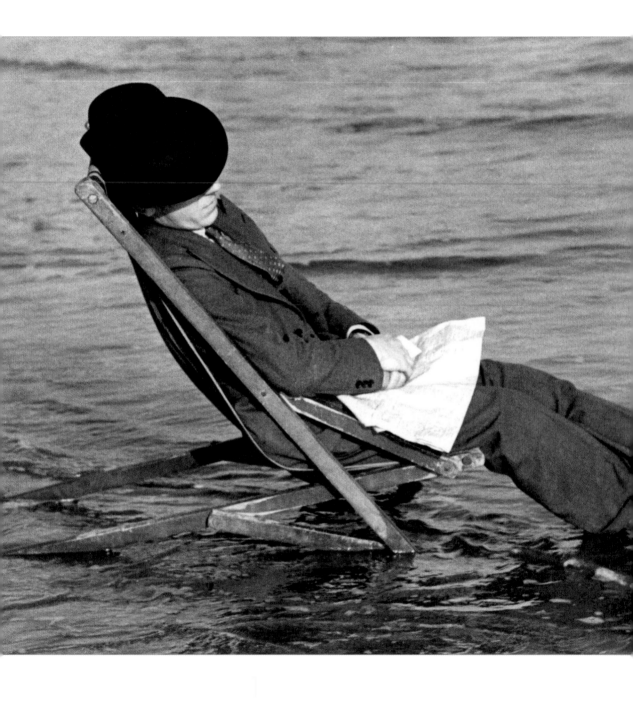

25

September

It's amazing that the amount of news
that happens in the world every day
always just exactly fits the newspaper.

– Jerry Seinfeld

26

September

I like the word "indolence".
It makes my laziness seem classy.

– Bernard Williams

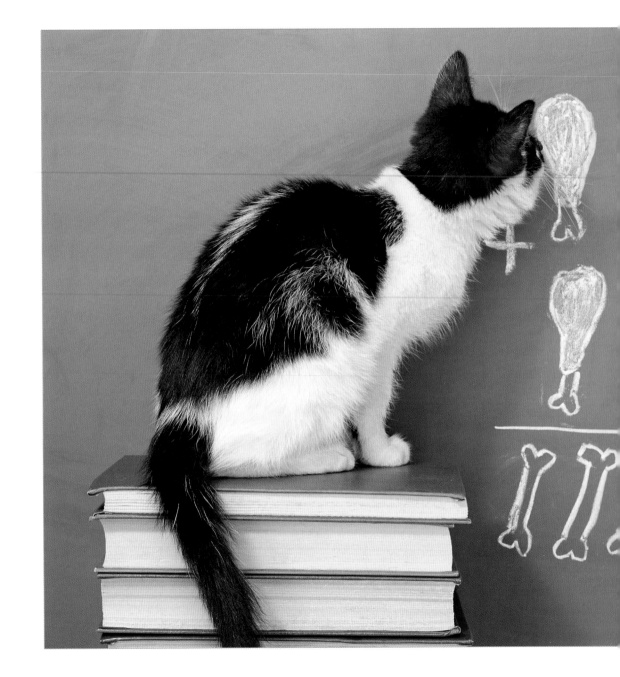

27
September

There is always an easy solution
to every human problem—
neat, plausible, and wrong.

– Henry L. Mencken

28
September

It doesn't matter whether
a cat is black or white,
so long as it catches mice.

– Deng Xiaoping

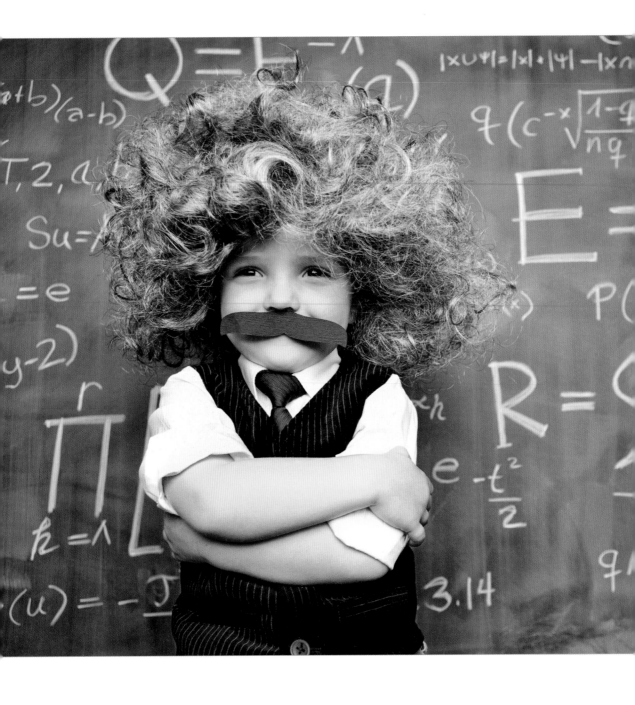

Logic will get you from A to B.
Imagination will take you everywhere.

– Albert Einstein

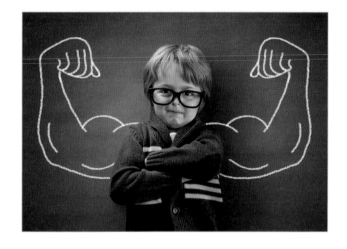

30
September

Macho does not
prove mucho.

– Zsa Zsa Gabor

1

October

If you could stay as stubborn
as when you were a child
then you need not compromise
on your dreams.

– Amit Kalantri

OCTOBER

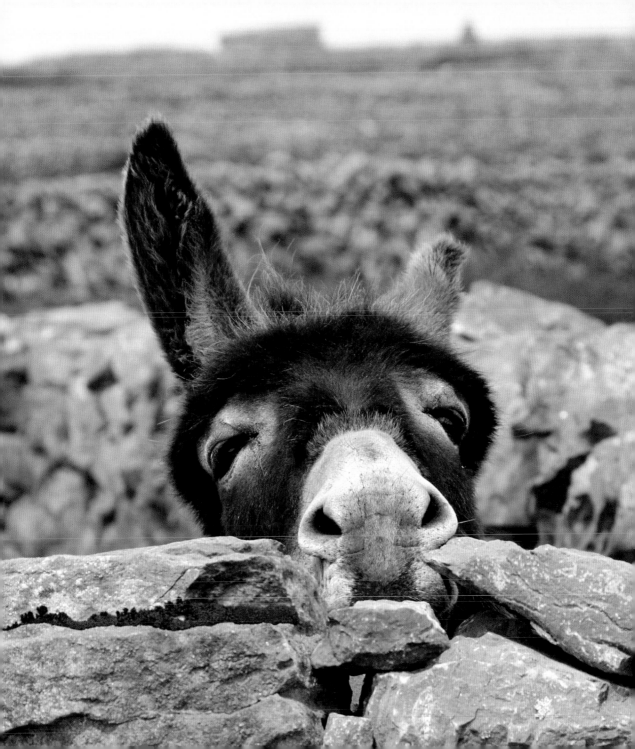

2

October

Happiness does not have
a price tag so smile.

– Jade Lebea

3

October

A smile is a curve that sets
everything straight.

– Phyllis Diller

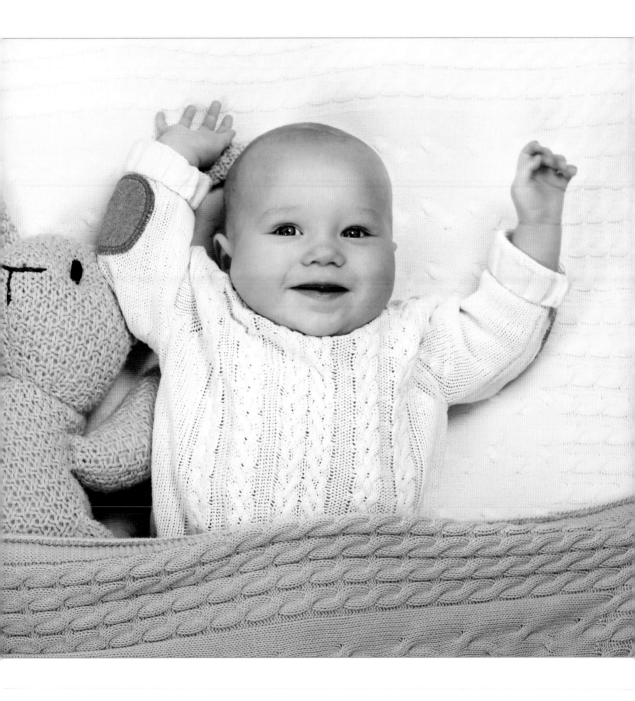

4

October

Children are our most valuable natural resource.

– Herbert Hoover

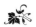

5

October

Life is the art of drawing without an eraser.

– John W. Gardner

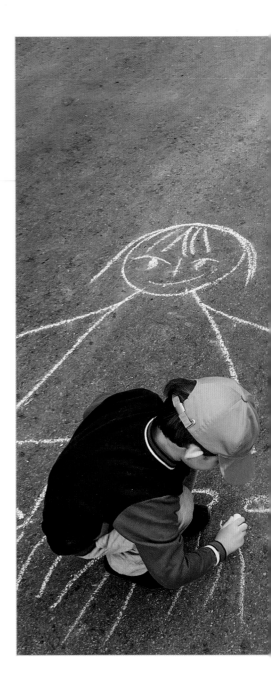

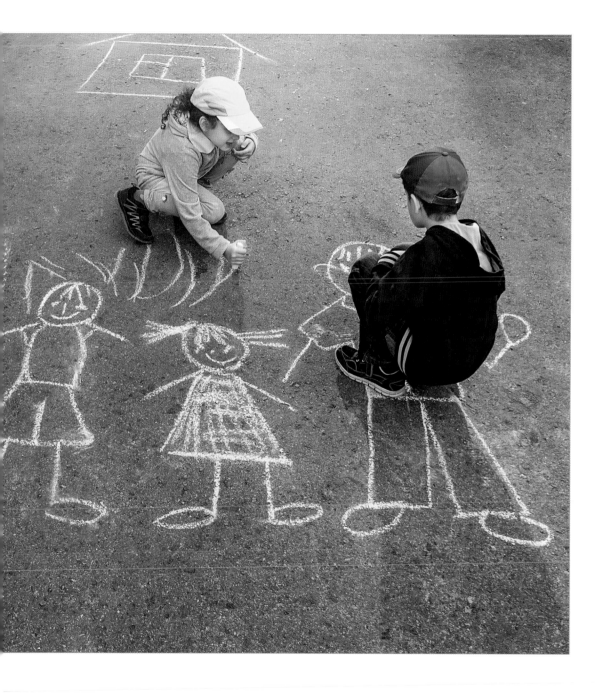

6
October

If you cannot do great things,
do small things in a great way.

– Napoleon Hill

7
October

I'm not small!
It's the world that's too big!

– Hiromu Arakawa

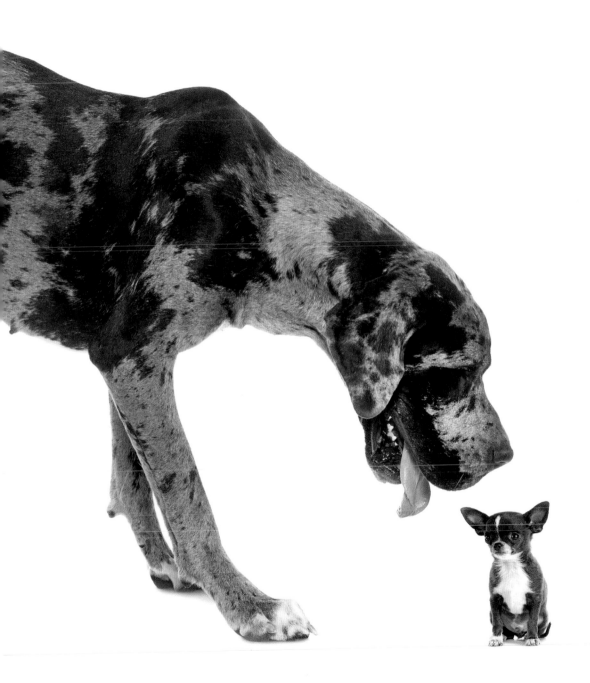

8

October

A family without a black sheep
is not a typical family.

– Heinrich Böll

9

October

If you climb into the saddle,
be ready for the ride.

– Cowboy saying

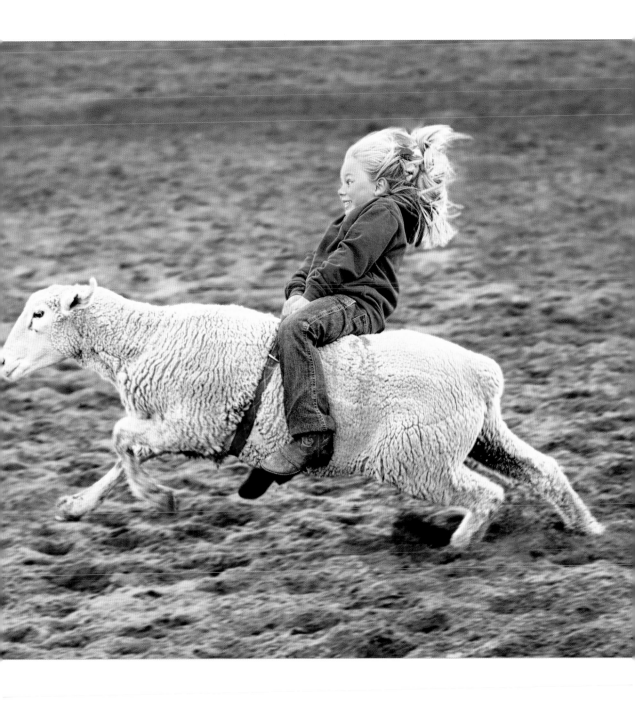

10
October

Wisdom comes from experience.
Experience is often a result
of lack of wisdom.

– Terry Pratchett

11
October

Photography helps
people to see.

– Berenice Abbott

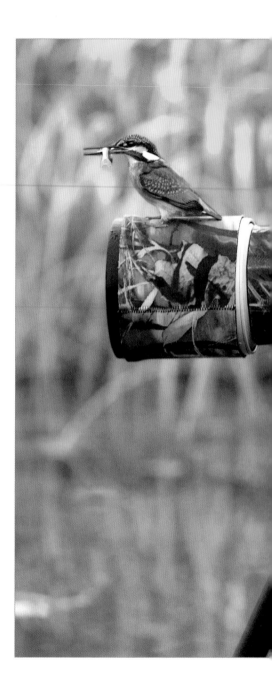

12

October

Constant togetherness is fine—
but only for Siamese twins.

– Victoria Billings

13

October

To be able to look back upon one's life
in satisfaction, is to live twice.

– Khalil Gibran

14
October

I'm an optimist, but an optimist
who carries a raincoat.

– Harold Wilson

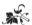

15
October

The way I see it,
if you want the rainbow,
you gotta put up with the rain.

– Dolly Parton

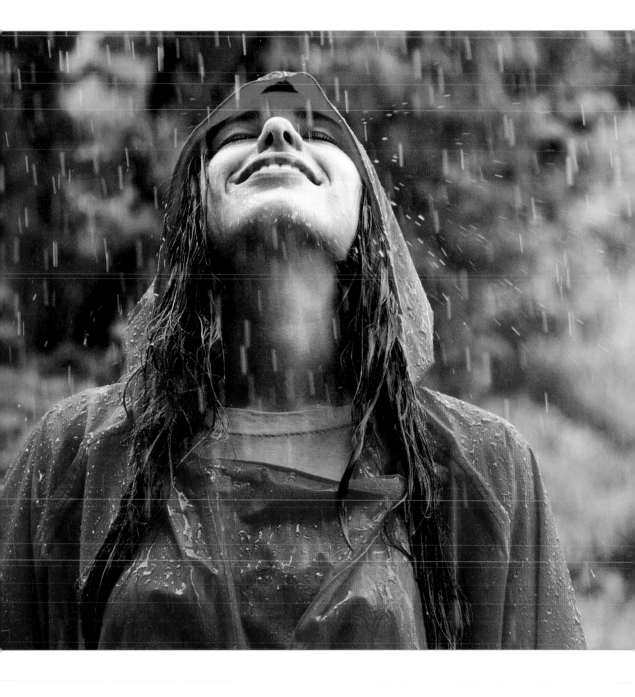

16
October

To be an ideal guest,
stay at home.

– Edger W. Howe

17
October

This suspense is terrible.
I hope it will last.

– Oscar Wilde

18
October

Never stand between
a dog and the fire hydrant.

– John Peer

19
October

If you are a dog and your owner
suggests that you wear a sweater
suggest that he wear a tail.

– Fran Lebowitz

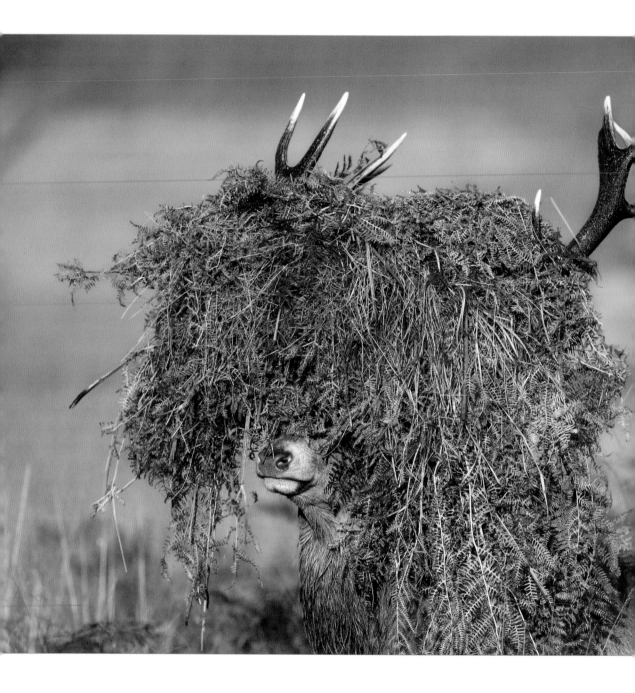

20
October

Love is blind;
friendship closes its eyes.

– Friedrich Nietzsche

21
October

The hardest thing to see is
what is in front of your eyes.

– Johann Wolfgang von Goethe

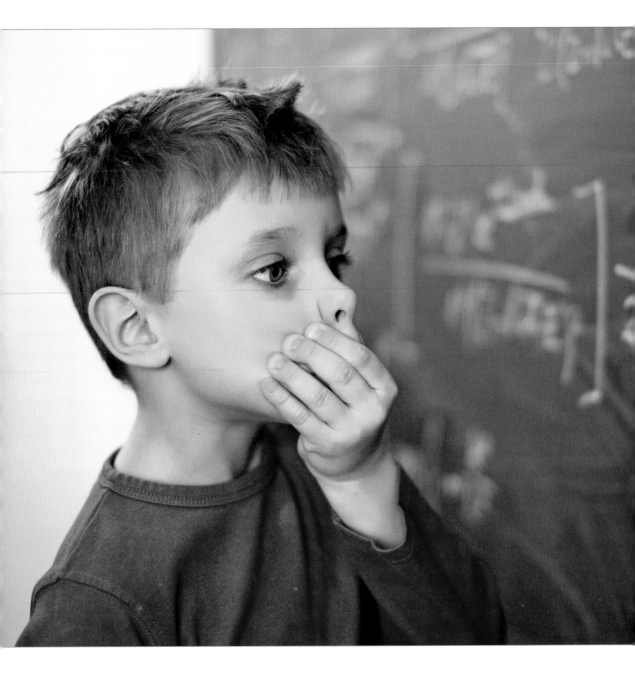

22

October

A child of five would understand this.
Send someone to fetch a child of five.

– Groucho Marx

23

October

"Obvious" is the most
dangerous word in mathematics.

– Eric T. Bell

24
October

Only the guy who isn't rowing
has time to rock the boat.

– Jean-Paul Sartre

25
October

Someone asked me, If I were stranded
on a desert island what book would
I bring . . . "How to build a boat."

– Steven Wright

26
October

The road to success
is always under construction.

– Lily Tomlin

27
October

When you're curious, you find lots
of interesting things to do.

– Walt Disney

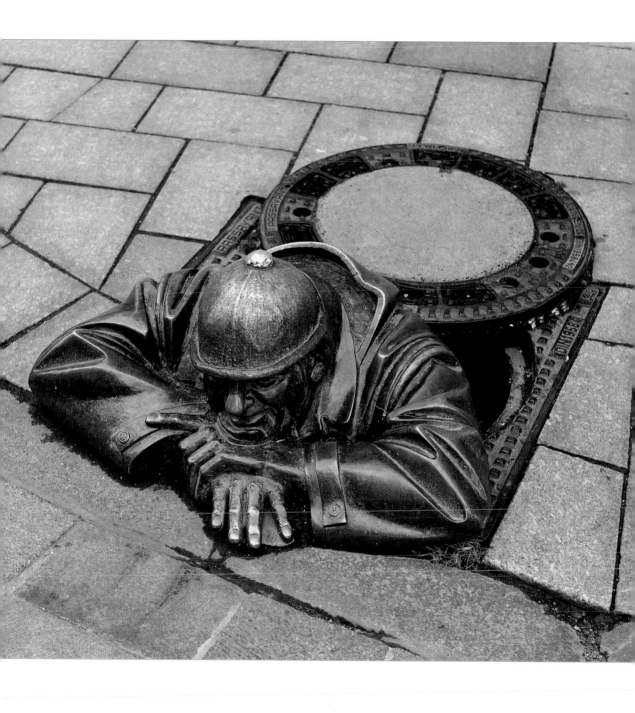

28

October

Beware, so long as you live,
of judging men by their
outward appearance.

– Jean de la Fontaine

29

October

First appearance
deceives many.

– Phaedrus

30
October

If this is coffee,
please bring me some tea;
but if this is tea,
please bring me some coffee.

– Abraham Lincoln

31
October

Go to Heaven for the climate,
Hell for the company.

– Mark Twain

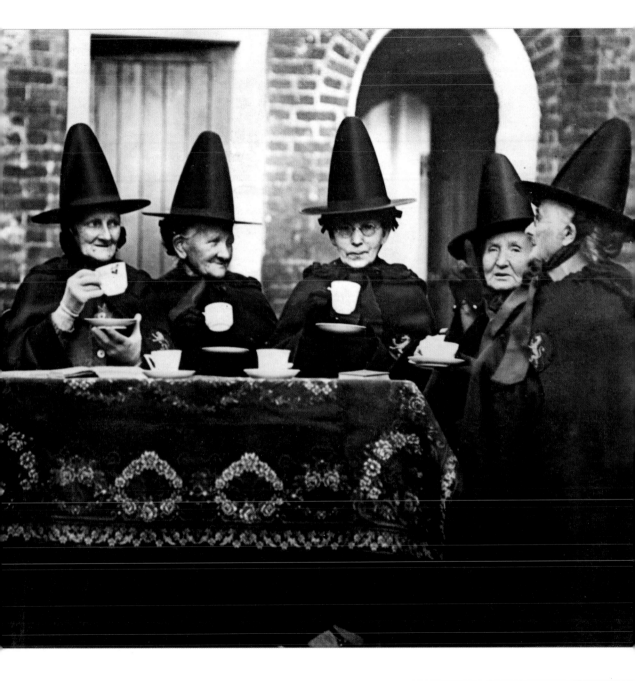

1

November

Most truths are so naked
that people feel sorry for them
and cover them up, at least a little bit.

– *Edward R. Murrow*

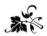

NOVEMBER

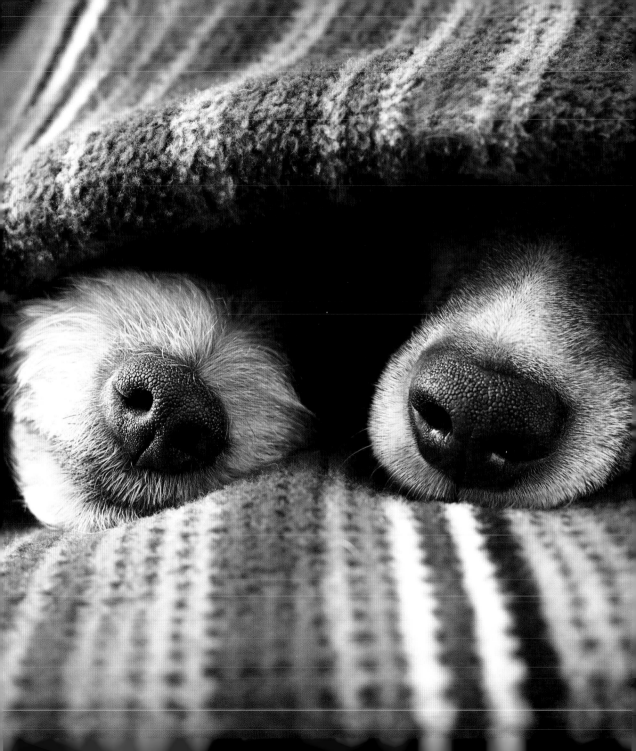

2

November

A hug is like a boomerang—
you get it back right away.

– Bil Keane

3

November

The capacity for friendship is God's way
of apologizing for our families.

– Jay McInerney

4

November

A friend is a gift you give yourself.

– Robert Louis Stevenson

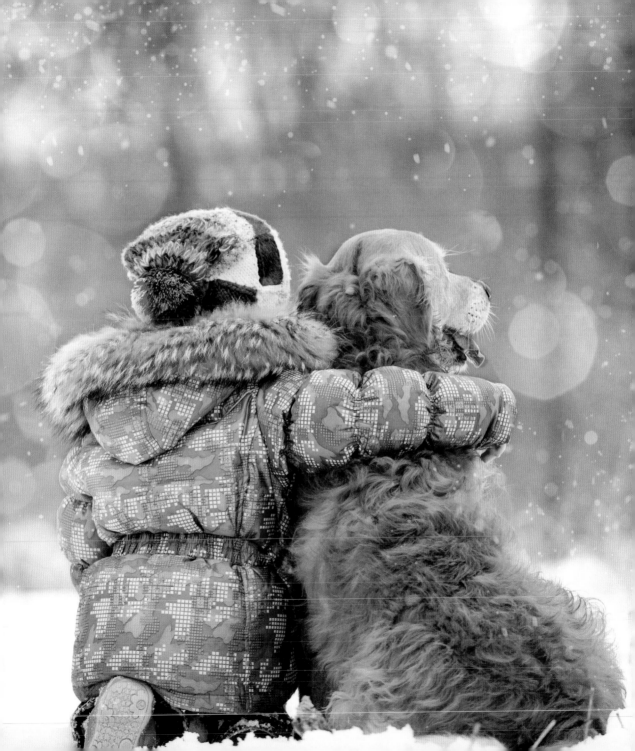

5
November

Snow provokes responses
that reach right back to childhood.

– Andy Goldsworthy

6
November

I'm a night owl for sure.
I was born at 1 a.m., and that's the excuse I use.

– Karla Souza

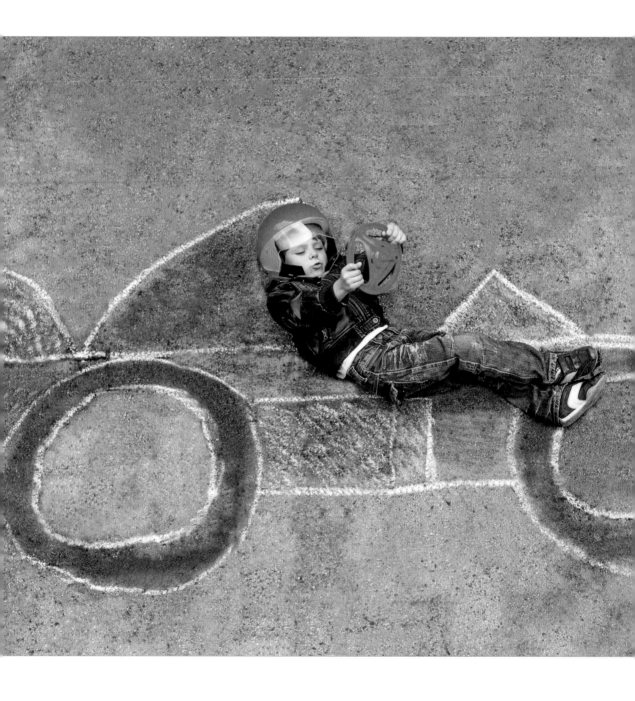

7
November

Low self-esteem is like driving through life
with your hand brake on.

– Maxwell Maltz

8
November

Grown-ups never understand anything
for themselves, and it is tiresome
for children to be always and forever
explaining things to them.

– Antoine de Saint-Exupéry

9

November

A person without a sense of humor
is like a wagon without springs.
It's jolted by every pebble on the road.

– Henry Ward Beecher

10

November

Every day is a journey,
and the journey itself is home.

– Matsuo Basho

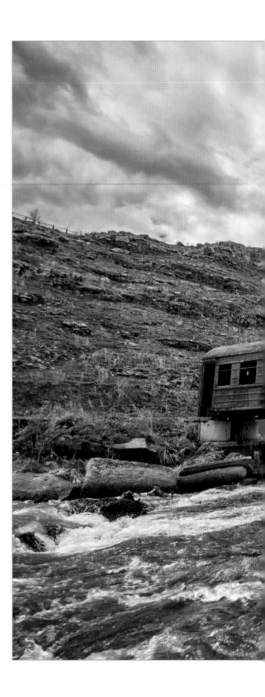

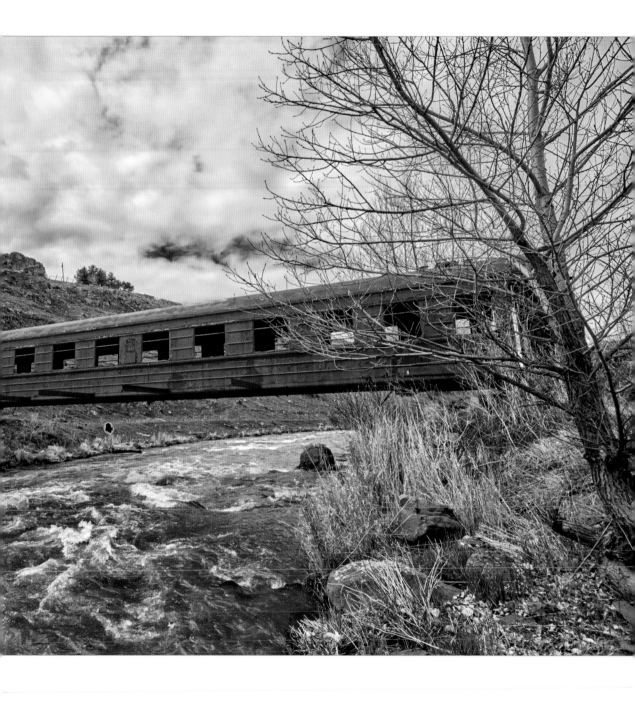

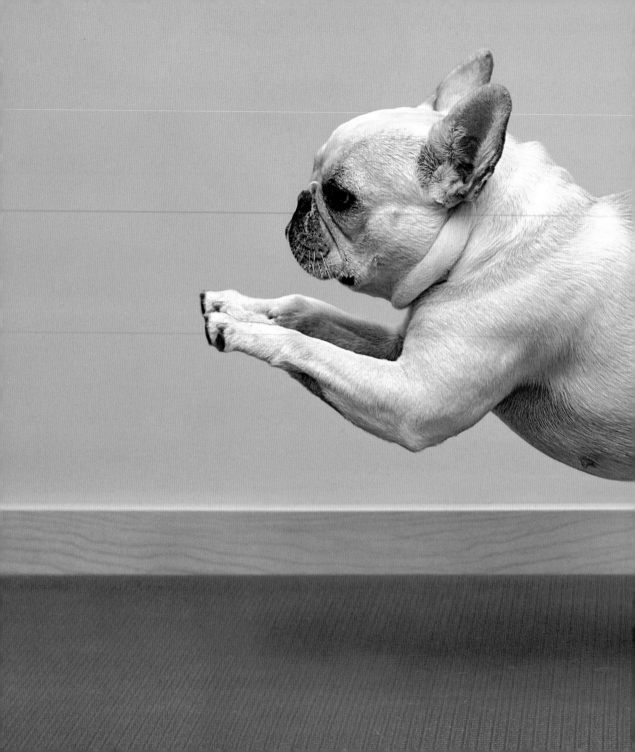

11
November

The dog is the perfect portrait subject.
He doesn't pose. He isn't aware of the camera.

– Patrick Demarchelier

12

November

Great things in business
are never done by one person.
They're done by a team of people.

– Steve Jobs

13

November

Life is a shipwreck
but we must not forget
to sing in the lifeboats.

– Voltaire

14

November

To do great things is difficult;
but to command great things
is more difficult.

– Friedrich Nietzsche

15

November

Two wrongs don't make a right,
but they make a good excuse.

– Thomas Szasz

16

November

My imagination
is a twisted place.

– Taylor Swift

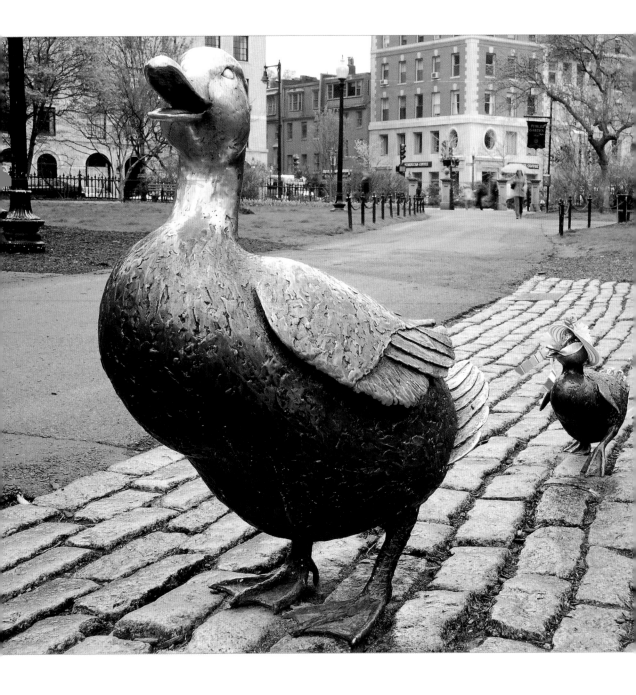

17
November

All right everyone,
line up alphabetically
according to your height.

– Casey Stengel

18
November

Elegance is all in the mind
of the wearer.

– Philip Treacy

19

November

What is pride? A rocket that emulates the stars.

– *William Wordsworth*

20

November

There are no passengers on spaceship Earth.
We are all crew.

– *Herbert Marshall McLuhan*

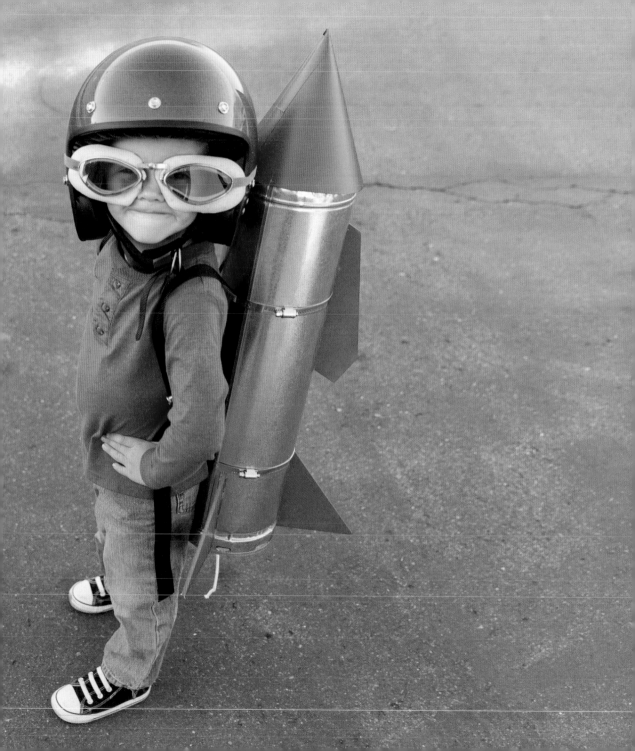

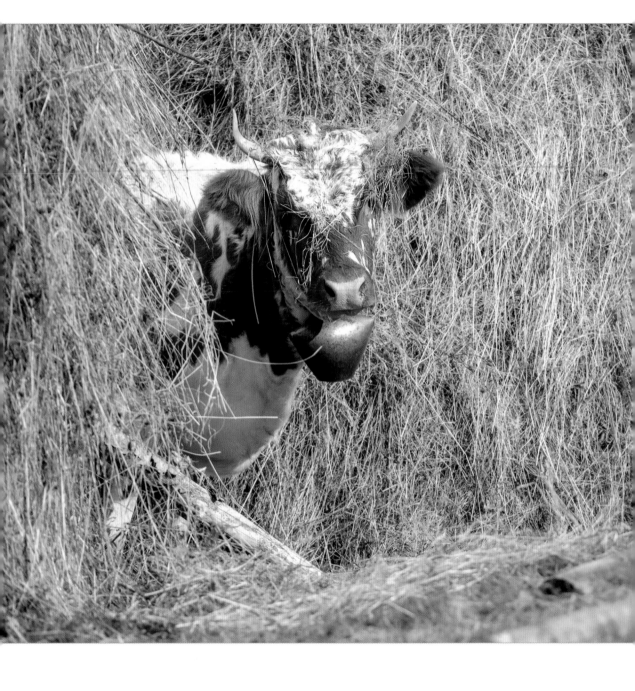

21

November

All the good ideas I ever had came to me
while I was milking a cow.

– Grant Wood

22

November

It is a joy to be hidden,
and disaster not to be found.

– Donald W. Winnicott

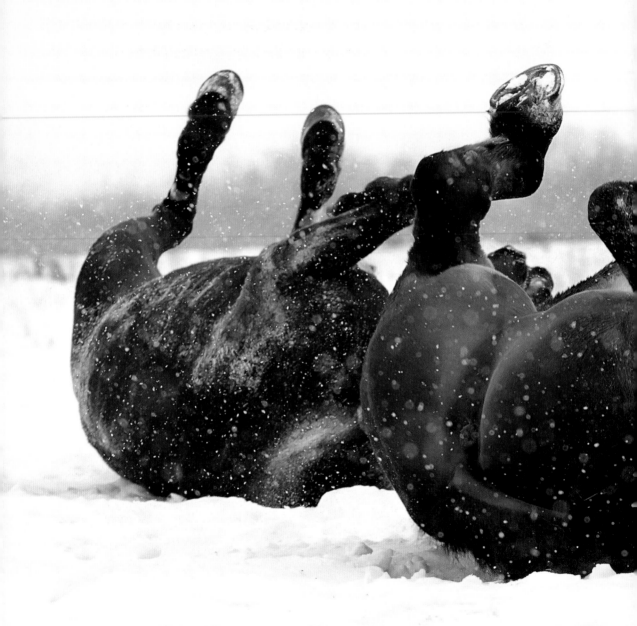

23

November

If you fall, fall on your back.
If you can look up, you can get up.

– Les Brown

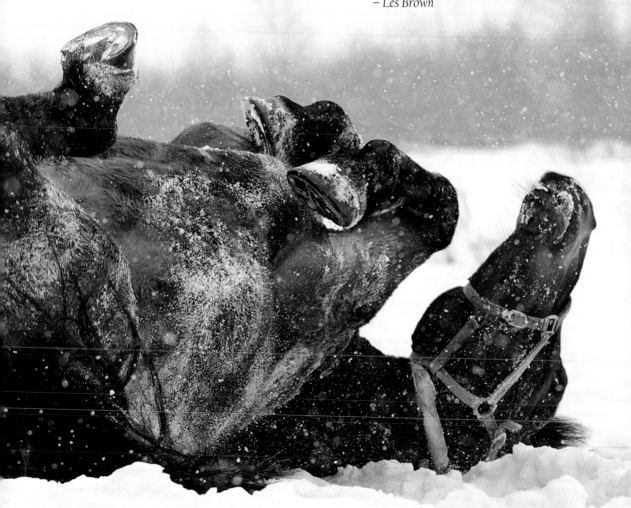

24

November

The gods are watching,
but idly, yawning.

– Mason Cooley

25

November

May your morning coffee
give you the strength to make it
to your mid morning coffee.

– Anonymous

26

November

Experience is a comb which nature
gives us when we are bald.

– Persian proverb

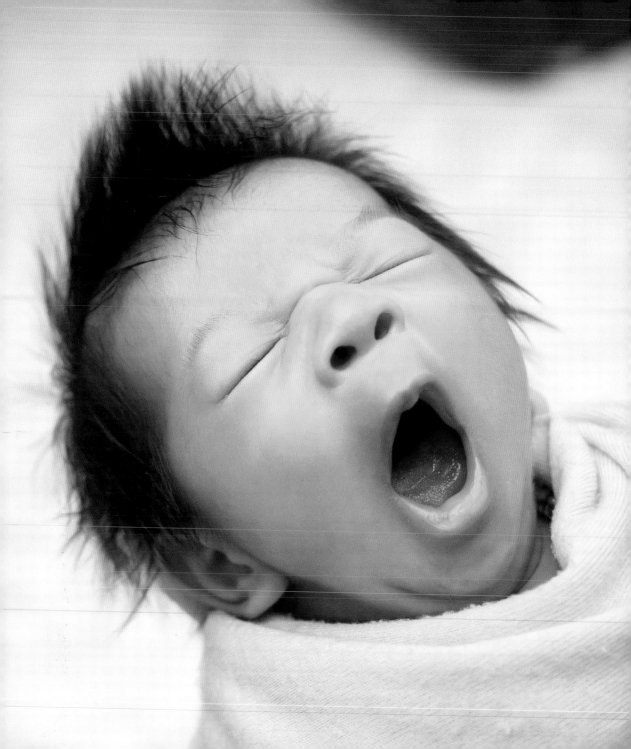

27

November

I'm not lacking in courage. It's the fear that does for me.

– Antonio Albanese

28

November

To bathe a cat takes brute force, courage—and a cat.
The last ingredient is usually hardest to come by.

– Stephen Baker

29

November

What I've learned is that life is a balance
between idealism and realism.

– Peter Hook

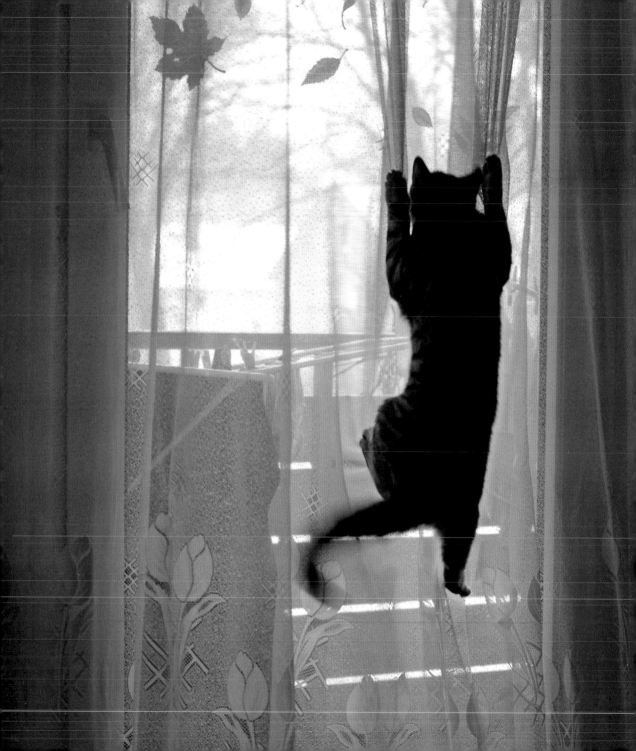

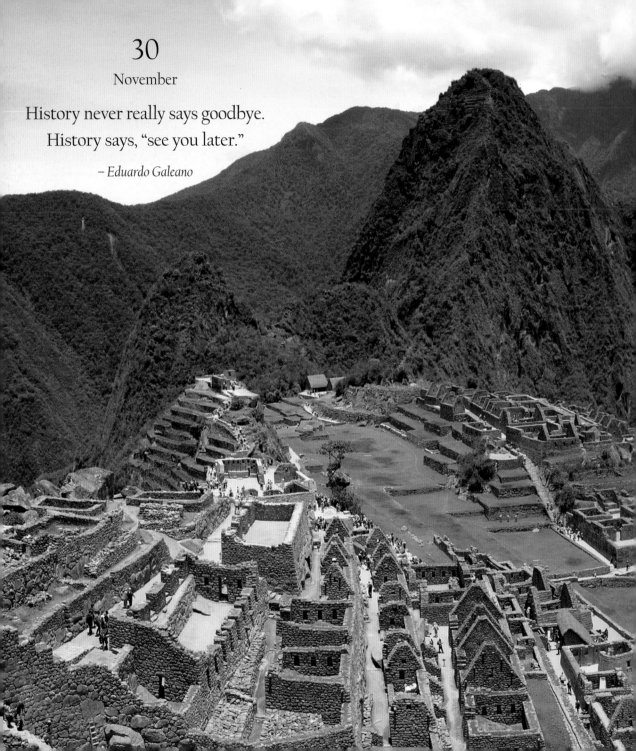

30
November

History never really says goodbye.
History says, "see you later."

– *Eduardo Galeano*

1

December

In the evening
every man looks the same.
Like penguins.
Women have a special dress
for that event;
men, the same tuxedo.

– Roberto Cavalli

DECEMBER

2

December

To be creative, you have to be crazy,
not because you're crazy
or want others to become crazy,
but because you must be crazy,
before others become crazy for you.

– Michael Bassey Johnson

3

December

If at first the idea is not absurd,
then there is no hope for it.

– Albert Einstein

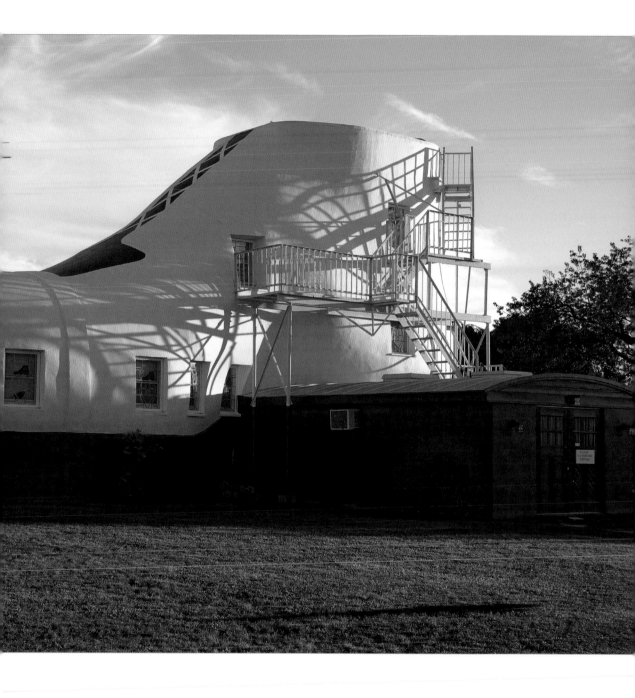

4

December

A kiss is a secret told to the mouth
instead of the ear; kisses are
the messengers of love and tenderness.

– Ingrid Bergman

5

December

People who throw kisses
are hopelessly lazy.

– Bob Hope

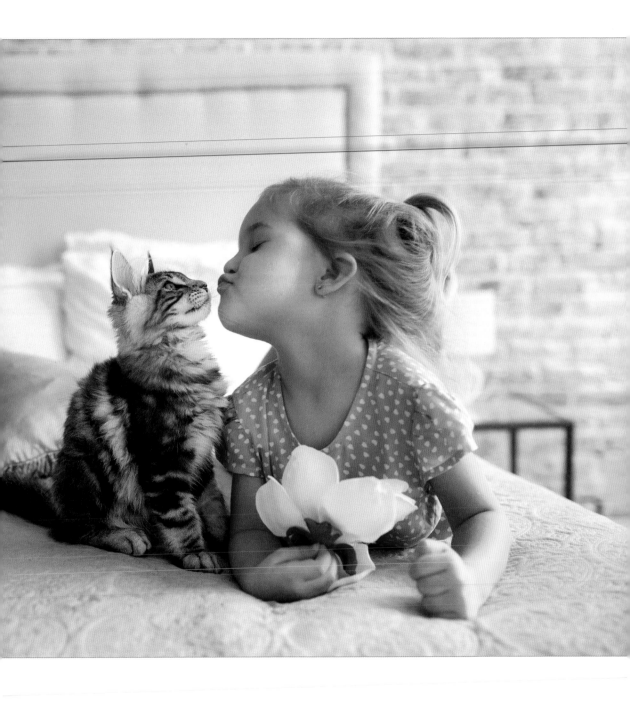

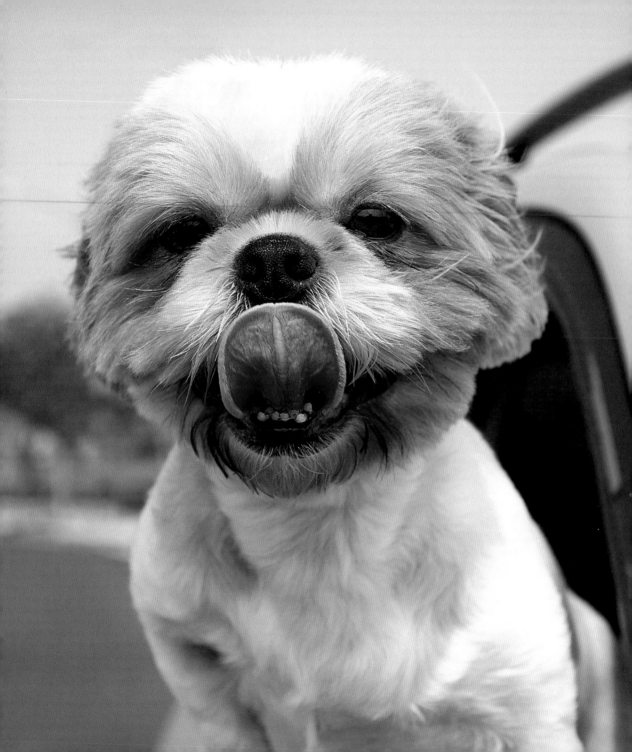

6
December

Never have more children
than you have car windows.

— Erma Bombeck

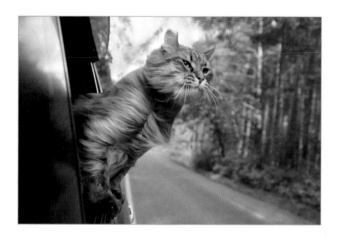

7
December

Time spent with cats
is never wasted.

– Sigmund Freud

8

December

Fantasy is hardly an escape from reality.
It's a way of understanding it.

– Lloyd Alexander

9

December

Angels can fly because
they take themselves lightly;
devils fall because of their gravity.

– Gilbert K. Chesterton

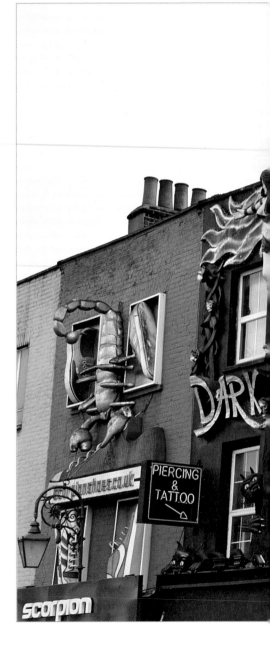

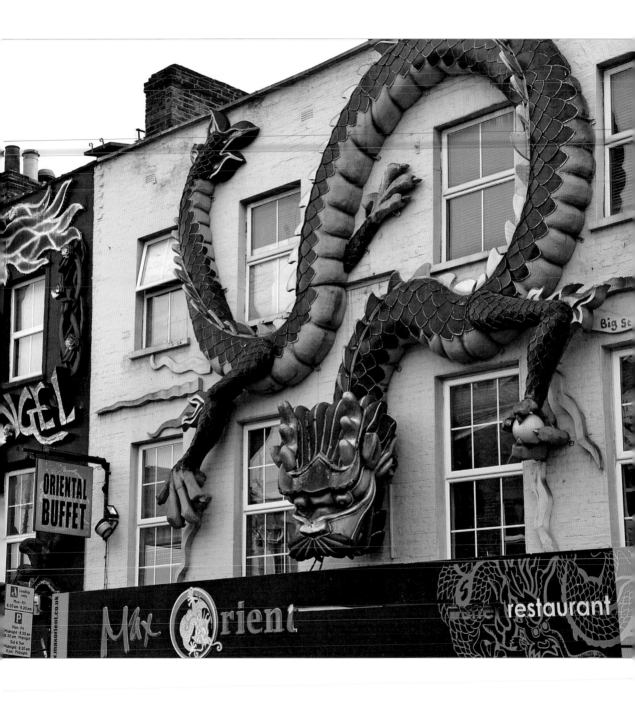

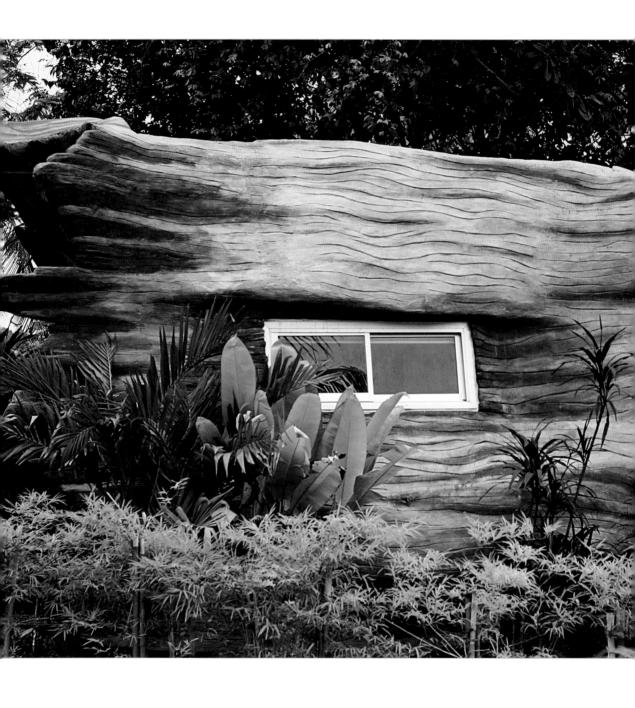

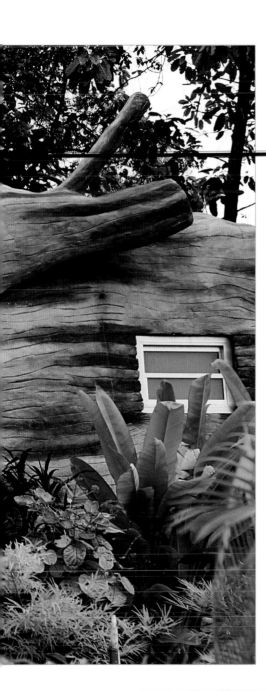

10

December

The ornament of a house
is the friends who frequent it.

– Ralph Waldo Emerson

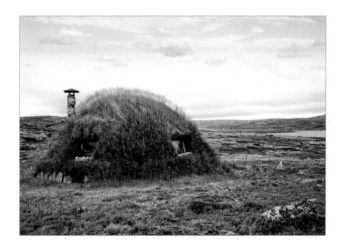

11

December

I had three chairs in my house;
one for solitude, two for
friendship, three for society.

– Henry David Thoreau

12

December

We have two ears and one tongue so that
we would listen more and talk less.

– Diogenes

13

December

If we were to measure philosophers by the length
of their beards, goats would be in first place.

– Lucian of Samosata

14

December

Opportunity does not knock, it presents itself
when you beat down the door.

– Kyle Chandler

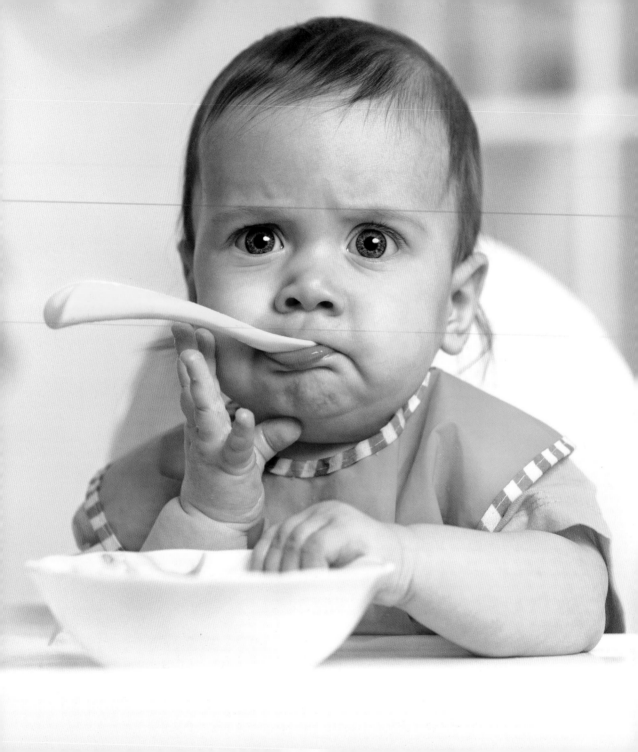

15

December

Comedy is simply a funny way of being serious.

– Peter Ustinov

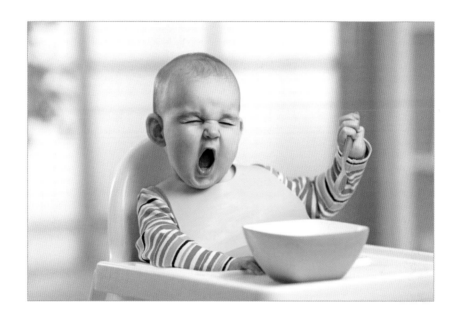

16

December

Humor keeps us alive. Humor and food.
Don't forget food. You can go a week without laughing.

– Joss Whedon

17
December

Imagination is something
that certain personalities cannot
even try to imagine.

– Gabriel Laub

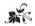

18
December

Art is the only way to run away
without leaving home.

– Twyla Tharp

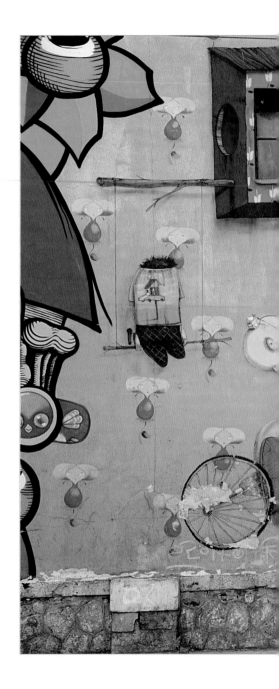

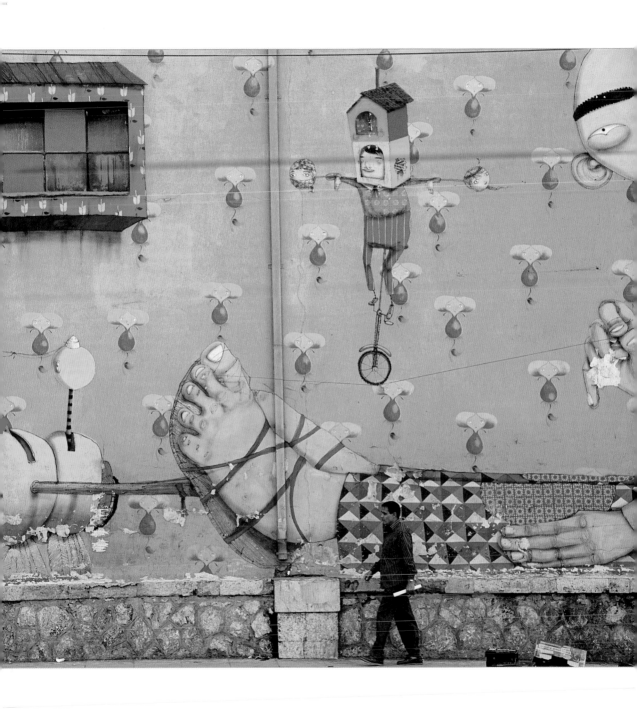

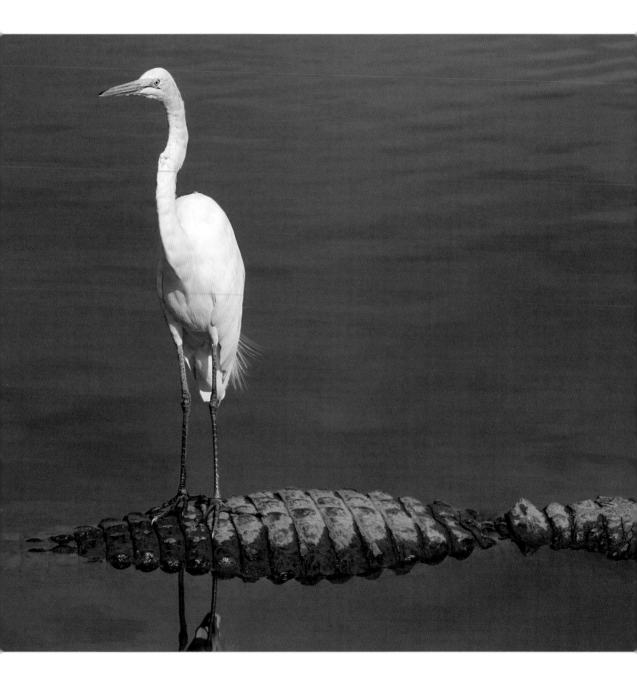

19
December

Risk isn't a word in my vocabulary.
It's my very existence.

– Slash

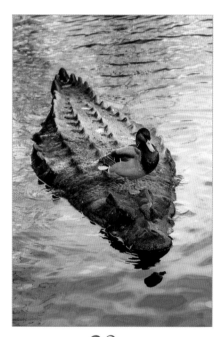

20
December

I done wrestled with an alligator, I done
tussled with a whale, handcuffed lightning,
and even thrown thunder in jail!

– Muhammad Ali

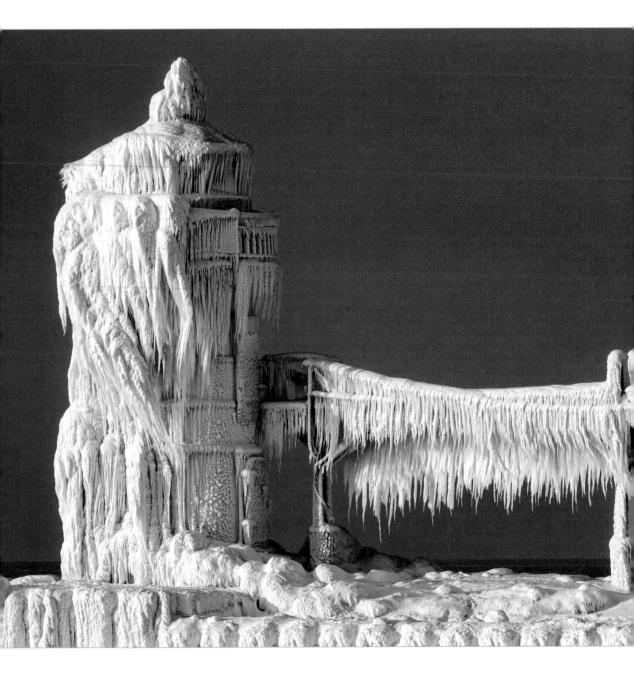

21

December

Inside my empty bottle
I was constructing a lighthouse while
all the others were making ships.

– Charles Simic

22

December

People don't notice whether it's winter
or summer when they're happy.

– Anton Chekhov

23

December

Quality is never an accident. It is always
the result of intelligent effort.

– John Ruskin

24
December

Don't worry about the world coming to an end today.
It is already tomorrow in Australia.

– Charles M. Schulz

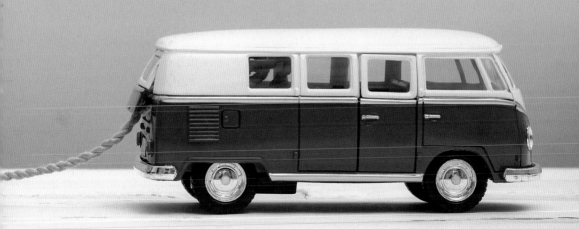

25

December

**Santa Claus has the right idea—
visit people only once a year.**

– Victor Borge

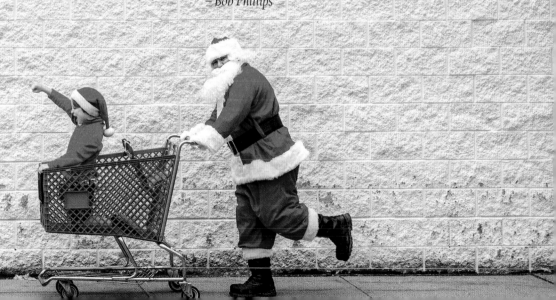

26

December

There are three stages of man: he believes in Santa Claus;
he does not believe in Santa Claus; he is Santa Claus.

– Bob Phillips

27

December

Evolution isn't true, because if we evolved from
monkeys, how can they still be here?

– *Stephen Baldwin*

28

December

Monkey, n.: an arboreal animal which makes
itself at home in genealogical trees.

– *Ambrose Bierce*

29

December

I've actually gone to the zoo and had monkeys shout to me from
their cages, "I'm in here when you're walking around like that?"

– *Robin Williams*

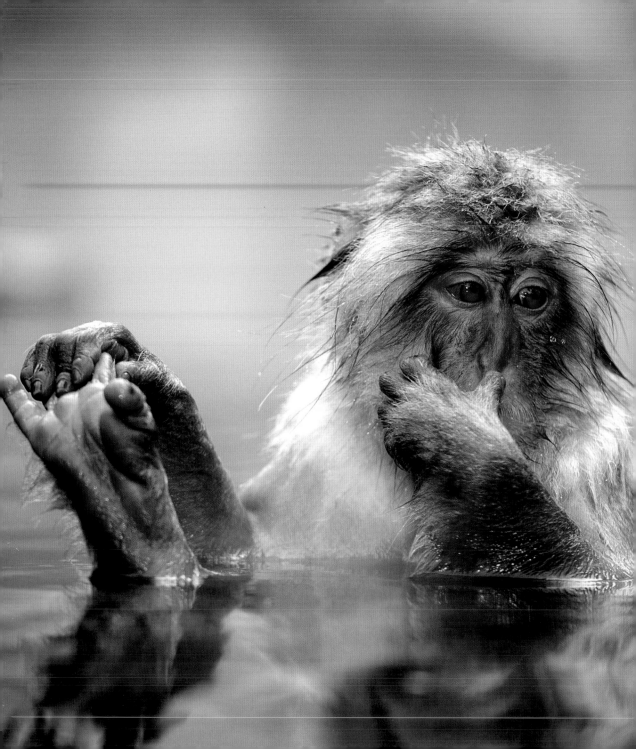

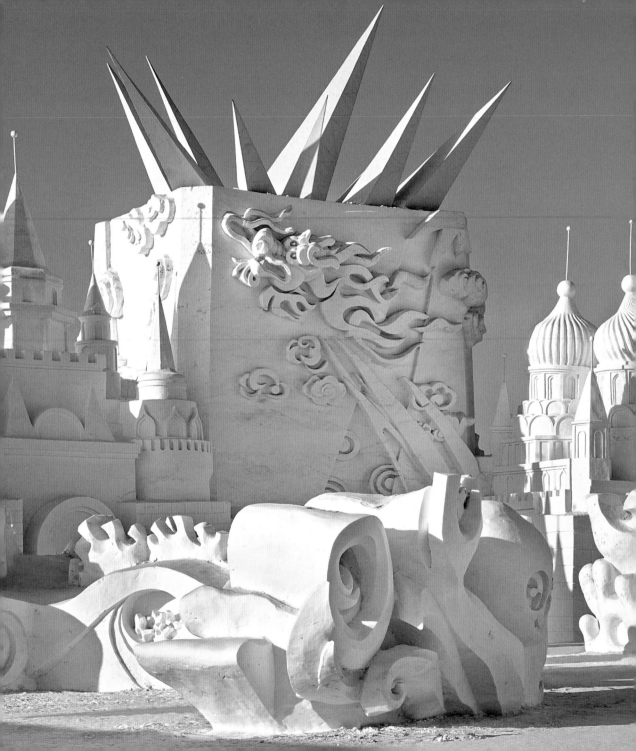

30
December

Getting an inch of snow
is like winning 10 cents
in the lottery.

– Bill Watterson

31
December

An optimist stays up
until midnight to see
the new year in. A pessimist
stays up to make sure
the old year leaves.

– Bill Vaughan

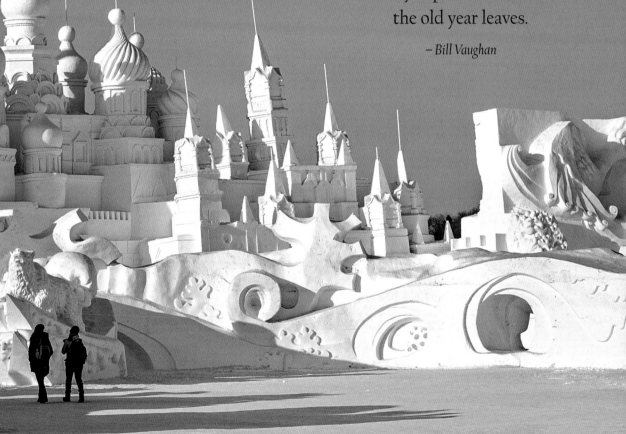

AUTHOR INDEX

O

O'Keeffe, Georgia, 1887-1986, American artist (23 February)

Olaf, character from the animated movie *Frozen* (2017), (4 February)

Orwell, George (Blair, Eric Arthur), 1903-1950, British journalist, essayist, and writer (16 March, 28 July)

P

Parker, Dorothy, 1893-1967, American writer, poetess, and journalist (13 May)

Parker, Sarah Jessica, 1965-, American actress (8 February)

Parton, Dolly, 1946-, American singer-songwriter, actress, and musician (15 October)

Pauley, Jane, 1950-, American television journalist and author (18 April)

Peer, John, (n. a.), American film producer (18 October)

Peter, Laurence J., 1919-1990, Canadian-American psychologist (16 June)

Peters, Tom, 1942-, American writer of business management (23 March)

Phaedrus, 14 BC-50 AD, Latin author (29 October)

Phelps, Michael, 1985-, American retired competitive swimmer (15 August)

Philips, Emo, 1956-, American actor and comedian (19 April)

Phillips, Bob, 1951-, American television journalist (26 December)

Picasso, Pablo, 1881-1973, Spanish painter and sculptor (10 February, 9 May)

Pigozzi, Jean, 1952-, French businessman, art collector, philanthropist, and photographer (13 April)

Pinchuk, Victor, 1960-, Ukrainian businessman (21 March)

Plait, Phil, 1964-, American astronomer, writer, and popular science blogger (22 March)

Plato, 428-347 BC, Greek philosopher (1 March)

Plaza, Aubrey, 1984-, American actress and comedian (9 July)

Pratchett, Terry, 1948-2015, British writer (14 May, 10 October)

Pratt, Chris, 1979-, American actor (20 July)

Pulitzer, Lilly, 1931-2013, American stylist (16 August)

R

Radner, Gilda, 1946-1989, American actress and comedian (2 January)

Reese, Betty, (n. a.), American television personality (31 August)

Renoir, Pierre-Auguste, 1841-1919, French painter (21 April)

Rey, Alain, 1928-, French linguist, lexicographer, and radio personality (10 September)

Rothfuss, Patrick, 1973-, American writer (15 June)

Ruiz Zafón, Carlos, 1964-, Spanish writer (12 June)

Ruskin, John, 1819-1900, British writer, poet, and art critic (23 December)

S

Saint-Exupéry, Antoine de, 1900-1944, French writer (31 March, 8 November)

Sandburg, Carl, 1878-1967, American poet (12 March)

Sartre, Jean-Paul, 1905-1980, French philosopher and writer (24 October)

Schulz, Charles Monroe, 1922-2000, American cartoonist (5 May, 11 August, 24 December)

Schwarzenegger, Arnold, 1947-, Austrian-American actor, producer, businessman, and politician (9 February)

Seinfeld, Jerry, 1954-, American stand-up comedian, actor, and screenwriter (10 June, 25 September)

Shaw, George Bernard, 1856-1950, Irish writer and playwright (1 June, 8 July, 29 August)

Simic, Charles (Simic, Dusan), 1938-, Serbian-American poet (21 December)

Slash (Hudson, Saul), 1965-, British-American musician and songwriter (19 December)

Snicket, Lemony (Handler, Daniel), 1970-, American writer (12 April, 27 June)

Souza, Karla, 1985-, Mexican actress (6 November)

Steinem, Gloria, 1934-, American journalist and activist (20 September)

Stengel, Casey, 1890-1975, American baseball right fielder and manager (13 September, 17 November)

Stepanek, Mattie, 1990-2004, American poet (10 January)

Stevens, Connie (Ingolia, Concetta Rosalie Ann), 1938-, American actress (24 August)

Stevenson, Robert Louis, 1850-1894, British writer (4 November)

Suggs, Lionel, 1989-, American writer (24 January)

Suzuki, Shinichi, 1898-1998, Japanese violinist (4 July)

Swift, Taylor, 1989-, American singer-songwriter (16 November)

Szasz, Thomas, 1920-2012, Hungarian-American academic, psychiatrist, and psychoanalyst (15 November)

PHOTO CREDITS

to; 9 and 10, Steven Heap/123RF; 11 and 12, Konstantin Aksenov/123RF; 13 and 14, Imgorthand/iStockphoto; 15, Kurit afshen/Shutterstock; 16, Kurit afshen/Shutterstock; 17, Alexander Ermolaev/123RF; 18, Alexander Ermolaev/123RF; 19 and 20, Viktoriya Ivanenko/Shutterstock; 21 and 22, evgovorov/iStockphoto; 23 and 24, Tom_Stables_Photography/iStockphoto; 25, Liukov/Shutterstock; 26, Martin Novak/Shutterstock; 27, photka/123RF; 28, Viktoriia Borysenko/123RF; 29, Oleg Zhukov/123RF; 30, Oleg Zhukov/123RF.

JULY

1, Freeartist/iStockphoto; 2 and 3, Alija/iStockphoto; 4 and 5, Human Activity On Mother Earth/Getty Images; 6 and 7, dmosreg/123RF; 8 and 9/10, NejroN/123RF; 11, Kannapon Phakdeesettakun/123RF; 12 and 13, dmosreg/123RF; 14 and 15, vitalinka/123RF; 16, visualspace/iStockphoto; 17, SeanPavonePhoto/iStockphoto; 18, VCG/VCG/Getty Images; 19, VCG/VCG/Getty Images; 20, Johan Swanepoel/123RF; 21 and 22, Saimon STUDIO/Shutterstock; 23, SebastianKnight/iStockphoto; 24, Vaclav Volrab/123RF; 25 and 26, titoslack/iStockphoto; 27 and 28, Irina Kozorog/123RF; 29 and 30/31, Sergei Uriadnikov/123RF.

AUGUST

1, tenra/123RF; 2 and 3, dmosreg/123RF; 4, Katrina Elena/iStockphoto; 5 and 6, skodonnell/iStockphoto; 7, Katie Smith/123RF; 8 and 9, ulkas/iStockphoto; 10 and 11, 1001slide/iStockphoto; 12 and 13, MykolaSenyuk/iStockphoto; 14, zona/iStockphoto; 15 and 16/17, dmosreg/123RF; 18 and 19/20, Arif Supriyadi/Shutterstock; 21 and 22, Mark Bridger/123RF; 23 and 24/25, Aleksey Mnogosmyslov/123RF; 26, leoba/123RF; 27 and 28/29, Martin Novak/Shutterstock; 30 and 31, Mark Bridger/123RF.

SEPTEMBER

1, F3al2/iStockphoto; 2 and 3, artemrybchak/Shutterstock; 4 and 5/6, Everett Collection/Shutterstock; 7 and 8, abramovtv/123RF; 9, evenfh/iStockphoto; 10, MichaelWarrenPix/iStockphoto; 11 and 12, Webkatrin001/iStockphoto; 13 and 14, Igor Daniel/123RF; 15 and 16, bjmc/iStockphoto; 17 and 18, Olga Bosnak/123RF; 19, Igor Plotnikov/123RF; 20, Igor Plotnikov/123RF; 21, Tomas Maracek/iStockphoto; 22, ammit/123RF; 24, Milan Bruchter/123RF; 25 and 26, Richards/Getty Images; 27 and 28, dtv2/iStockphoto; 29, RichVintage/iStockphoto; 30, BrianAJackson/iStockphoto.

OCTOBER

1, driftlessstudio/iStockphoto; 2 and 3, famveldman/123RF; 4 and 5, Yuliya Evstratenko/Shutterstock; 6 and 7, Bonzami Emmanuelle/123RF; 8 and 9, LifeJourneys/iStockphoto; 10 and 11, DieterMeyrl/iStockphoto; 12 and 13, iom/iStockphoto; 14 and 15, Hquality/Shutterstock; 16, StockPhotosArt/iStockphoto; 17, PeterAustin/iStockphoto; 18 and 19, OlgaOvcharenko/Shutterstock; 20 and 21, GP232/iStockphoto; 22 and 23, Imgorthand/iStockphoto; 24 and 25, dinozaver/iStockphot; 26 and 27, Michele Falzone/Getty Images; 28, Juli Scalzi/123RF; 29, kokodrill/123RF; 30 and 31, George Rinhart/Corbis/Getty Images.

NOVEMBER

1, damedeeso/iStockphoto; 2 and 3/4, gekaskr/123RF; 5 and6, Jim_Pintar/iStockphoto; 7, romrodinka/iStockphoto; 8, romrodinka/iStockphoto; 9 and 10, Vitaly Titov/123RF; 11, BenGrantham/iStockphoto; 12 and 13/14, davelogan/iStockphoto; 15, ValerioMei/iStockphoto; 16, ValerioMei/iStockphoto; 17 and 18, James Kirkikis/123RF; 19 and 20, RichVintage/iStockphoto; 21 and 22, Ivan Kmit/123RF; 23, Yulia Chupina/123RF; 24 and 25/26, muaotphoto/iStockphoto; 27 and 28/29, isumi/iStockphoto; 30, Oktay Ortakcioglu/iStockphoto.

DECEMBER

1, norbiy/iStockphoto; 2 and 3, gsheldon/iStockphoto; 4 and 5, PhotoSunny/Shutterstock; 6, Wang Tom/123RF; 7, Arsenii Popel/123RF; 8 and 9, Maisna/iStockphoto; 10, Ginaellen/iStockphoto; 11, alxpin/iStockphoto; 12 and 13/14, Nataliya Hora/123RF; 15, oksun70/iStockphoto; 16, Oksana Kuzmina/123RF; 17 and 18, GrigoriosMoraitis/iStockphoto; 19, JamesBrey/iStockphoto; 20, dennisvdw/iStockphoto; 21, gnagel/iStockphoto; 22, toshiake/iStockphoto; 23 and 24, ampcool/Shutterstock; 25 and 26, CHBD/iStockphoto; 27 and 28/29, Charoen Munbunjong/123RF; 30 and 31, aphotostory/iStockphoto.

Project Editor
Valeria Manferto De Fabianis

Texts
Iceigeo, Milan (Carlo Batà, Giulia Gatti,
Simone Gramegna)

Graphic Design
Valentina Giammarinaro

Collaborating Editor
Giorgio Ferrero

WS White Star Publishers® is a registered trademark
property of White Star s.r.l.

© 2018 White Star s.r.l.
Piazzale Luigi Cadorna, 6 - 20123 Milan, Italy
www.whitestar.it

Translation and Editing: Iceigeo, Milan (Carlo Batà, Giulia
Gatti, Simone Gramegna/Katherine M. Clifton)

ISBN 978-88-544-1304-7
1 2 3 4 5 6 22 21 20 19 18

Printed in Italy by Rotolito S.p.A. - Seggiano di Pioltello (MI)